SATYAJIT RAY ON CINEMA

SATYAJIT RAY ON CINEMA

Satyajit Ray

Edited by Sandip Ray

In association with

Dhritiman Chaterji, Arup K. De,
Deepak Mukerjee, and Debasis Mukhopadhyay

Foreword by

Shyam Benegal

COLUMBIA UNIVERSITY PRESS
NEW YORK

Columbia University Press
Publishers Since 1893
New York Chichester, West Sussex
cup.columbia.edu
Copyright © 2011 Sandip Ray, Bijoya Ray
All rights reserved

First published in India in 2011 by HarperCollins Publishers India
www.harpercollins.co.in

Library of Congress Cataloging-in-Publication Data

Ray, Satyajit, 1921–1992.
Satyajit Ray on cinema / Satyajit Ray ; edited by Sandip Ray ; in association
with Dhritiman Chaterji, Arup K. De, Deepak Mukerjee, and
Debasis Mukhopadhyay ; foreword by Shyam Benegal.
pages cm
Includes bibliographical references and index.
ISBN 978-0-231-16494-8 (cloth : alk. paper) — ISBN 978-0-231-16495-5
(pbk. : alk. paper) — ISBN 978-0-231-53547-2 (e-book)
1. Ray, Satyajit, 1921–1992. 2. Motion picture producers and directors—
India—Biography. 3. Motion pictures. I. Ray, Sandip, editor
of compilation. II. Title.

PN1998.3.R4A3 2013
791.4302'33092—dc23 [B] 2012039149

Columbia University Press books are printed on permanent and durable
acid-free paper.
This book is printed on paper with recycled content.
Printed in the United States of America

c 10 9 8 7 6 5 4 3 2 1
p 10 9 8 7 6 5 4 3 2 1

Cover design: Michelle Taormina
Cover photo: Society for the Preservation of Satyajit Ray Films

Photographs and images courtesy of the Society for the
Preservation of Satyajit Ray Films.
Images from the collection of B.D. Garga are courtesy
of Donnabelle Garga.

References to websites (URLs) were accurate at the time of writing.
Neither the author nor Columbia University Press is responsible for URLs
that may have expired or changed since the manuscript was prepared.

CONTENTS

PREFACE

SATYAJIT RAY, MY late father, published *Our Films Their Films*, his first collection of essays in English, in 1976. That remained his only original book on cinema in that language till the appearance of the present volume containing articles written since 1949, well before he became a film-maker.

It was some time ago that our Society decided to put together a book (or books) with articles by my father which lay scattered in newspapers and magazines both at home and abroad. But we had no idea exactly how many of them existed. My father never made a meticulous effort to preserve his published writings.

We had, however, a few articles in our archives. For others, we launched a search, a difficult one at that, as some of the dailies and periodicals where they had appeared were no longer extant. Our efforts ultimately yielded a number of essays and talks, long and short, which seemed good enough material for a full-fledged book. The search for more is still on.

These pieces, which were beyond access for contemporary readers for a long time, offer revealing insights into the evolution of my father's thoughts on aspects of cinema as a visual art, his own craft of film-making, and his views on such other great directors as Chaplin, Bergman, Godard and Antonioni.

This book would not have been possible but for the generous

support we received from Mr D.N. Ghosh, President of our Society and himself a distinguished author. We also take this occasion to thank V.K. Karthika and Shantanu Ray Chaudhuri, publisher and chief copy editor of HarperCollins *Publishers* India, respectively, for the keen interest they took in the publication of this book.

SANDIP RAY

Member Secretary
Society for the Preservation of Satyajit Ray Films,
Kolkata

FOREWORD

I WAS PROBABLY a trifle more passionate about going to the movies than my siblings or my peers at school. Before long, cinema became an extension not only of the world I occupied (from which it was altogether different) but also extended my imagination to an extraordinary degree to the vast expanse of the many universes of geography, history, mythology and fantasy, otherwise locked up between the covers of books.

Making up my mind that all I wanted to do when I grew up was to make my own films gave me a licence to indulge my film-watching fancy much to the alarm of my parents. Discriminating films even from the point of view of enjoying some and not others developed over a period of time. This in turn was followed by seeking out films that one liked and working out the reasons for doing so. While still in school, I already had favourite directors alongside film stars. These films were marked out for repeat viewing. The films that were available for viewing at the time were mostly English-language films from Hollywood and Hindi films with a smattering of an odd Marathi film from Poona. The clear favourites among the directors were John Ford, William Wyler, John Huston and a director pair from Britain, Michael Powell and Emeric Pressburger. Hindi films by Mehboob, Sohrab Modi, Shantaram, Fatehlal and Damle were the ones I looked

forward to seeing. I had yet to discover film-makers from other parts of the world.

Soon after I entered college I had my very first exposure to films from Europe, particularly Italy. *Bicycle Thieves, Shoeshine, Miracle in Milan* and *Bitter Rice* were among them. These had come as part of the First International Film Festival held in India and had presumably found Indian distributors. Some Soviet films came in at the time and I saw Mark Donskoi's films based on Maxim Gorky's novels apart from *Battleship Potemkin* and the first part of *Ivan the Terrible*. I found the film experience offered by these films far greater than most of the films I had seen before this. Soon enough, an Indian film caught my eye: Bimal Roy's *Do Bigha Zameen*.

Not long afterwards on a trip to Kolkata, an uncle who lived there strongly recommended that I see a Bengali film made by a first-time film-maker. I saw the film in a south Kolkata cinema where it was playing. It was an afternoon show and the film was *Pather Panchali*. The experience was indescribable. As the expression goes, 'it simply blew my mind'. When the show ended I rushed back to the box office and bought a ticket for the next show and went back yet again for the show after that. I saw the film several times over in the next couple of days before I returned home to Hyderabad. Here was a film, the like of which I had never seen before. And here was a film-maker who had broken free of the conventions of both Hollywood and Indian cinema.

Satyajit Ray had shattered the mould that had bound film-makers in India to a form of film-making that had remained unchanged since the introduction of sound. By a strange coincidence, this was also a time of revolutions in the cinemas of Europe: Italian Neo-realism, French Nouvelle Vague, the Free Cinema of Britain and the post-war films from northern, central and eastern Europe. All these had taken cinema to an exciting

new phase. Far more significant to me than any of these developments was this single film by a first-time Indian filmmaker in a film language and idiom that was both modern and entirely his own. The locations and the people in the film were believable and culture specific. It was beyond anything that I had imagined films of being capable of achieving; a true watershed in Indian cinema.

Satyajit Ray had arrived. He was a game changer in what until then was bound largely by conventions that had evolved entirely on the basis of commercial valuation of films by the cinema industry relying on narrative styles taken directly from the urban theatre that preceded it. Soon after came his younger contemporaries, Ritwik Ghatak and Mrinal Sen, who created their own individual styles in cinema, making Bengal once again a trendsetter, this time in cinema. For someone like me, who had film-making ambitions, *Pather Panchali* opened up a world of possibilities, helping me to break free from the web of film influences in which I was held. It compelled me to rethink fundamentally many of my views on how to create film narratives.

If there is a single contribution of Satyajit Ray to the world of Indian cinema it would be the path he created for Indian cinema to break free from being self-referential and imitative of subjects largely lifted from Hollywood films, in favour of a standardized urban view of the world that was largely the creation of nineteenth-century urban theatre.

Satyajit Ray set a very high benchmark for himself and eventually left behind an enviable oeuvre of films. The influence of Satyajit Ray on the many cinemas of India has been immense but rarely acknowledged. There are many areas of film-making where his influence has been felt in greater or lesser degree whether in acting styles, photography, production design, the use of sound and even in the creation of music scores which were rarely thematic before his time.

Equally, Ray was as creative and articulate in his writing as he was in his film-making. He is recognized as one of the best Indian writers of children's stories. He also wrote quite extensively on cinema.

The essays in the present collection have been chosen and compiled by his son Sandip Ray, in association with others including one of his favourite actors, Dhritiman Chaterji, with obvious care to see that his views come across with clarity and precision. Starting with an early essay that predates his film-making (1949) all the way to the last part of his career, Ray displays a remarkably consistent view of the cinema he favoured. His reflections and thoughts give us a wonderful insight into the nature of his aesthetics, the extraordinary ability he had of absorbing and internalizing folk and classical traditions both of the West and East to find a contemporary and modern voice.

The essays here show him to be equally concerned with both the craft and art of film-making. He was neither overtly ideological nor given much to theorizing. Some views expressed in his earliest essays are probably dated now. And his view of Popular Indian Cinema for which he had little time could also be considered somewhat elitist. If he had been more patient with popular cinema, he probably would have found some significant reasons why it held the largest number of people in our country in thrall. The longest essay in this collection, 'Under Western Eyes', which is also the most rewarding, could well be his film testament.

The present collection of essays in *Deep Focus* serves as an excellent introduction to Satyajit Ray's thoughts on cinema. It also opens yet another window to a deeper appreciation of his films. This is indeed a valuable addition to the not too many worthwhile books on Indian cinema.

1 October 2011 SHYAM BENEGAL

Part One

THE FILM-MAKER'S CRAFT

1

NATIONAL STYLES IN CINEMA

'LOOK AT THE flowers,' said Jean Renoir one day while on a search for suitable locales in a suburb of Calcutta for his film *The River*. 'Look at the flowers,' he said. 'They are very beautiful. But you get flowers in America too. Poinsettias? They grow wild in California, in my own garden. But look at the clump of bananas, and the green pond at its foot. You don't get that in California. That is Bengal, and that is [here Renoir used the one word that in his vocabulary meant wholehearted approval] fantastic.'

Among other things which Renoir thought fantastic and hoped to use in his film were a temple on the bank of the Hooghly ('so humble . . . maybe one man built it, and maybe the same man worships in it'); a boat – any boat – on the river ('ageless, like an Egyptian bas-relief'); a woman drawing water from a well; saris hanging from the verandahs of Bowbazar residences; the music of an anonymous flautist in Waterloo Street; the patterns of cow dung on the wall of a village hut . . .

The Statesman, 14 August 1949

Cinema being first and foremost a pictorial medium, and the integrity of atmosphere being the first essential of a good film, the problem which faced Renoir and which his painter's eye was able to solve with comparative ease was that of selecting the visual elements which would be pictorially effective, and at the same time truly evocative of the spirit of Bengal. And because the narrative technique of cinema admits of dawdling, these elements had to be the quintessential ones so that the director could make his points and create his atmosphere with a minimum of film footage.

Search for style

In searching for locations, therefore, Renoir was also searching for a style. But being an alien and a European, there is a limit to which he could probe into the complexity that is India. The most he could do was to concentrate on the external aspect and leave the rest to his own French sensibility.

In cinema, as in any other art, the truly indigenous style can be evolved only by a director working in his own country, in the full awareness of his past heritage and present environment.

In the days of the silent cinema, the film-makers of the world formed one large family. Using the technique of mime, which is a more or less universally understood language, they turned the cinema into a truly international medium. With the coming of sound, mime gave way to the spoken word and a new technique of realistic acting was evolved to suit the requirements of the medium. Not that stylization had to go. As Chaplin has demonstrated in *Monsieur Verdoux*, an Englishman can make a film about a Frenchman in an American studio, and yet invest it with a basic universal appeal. But the main contribution of sound was an enormous advance towards realism, and a

consequent enrichment of the medium as an expression of the ethos of a particular country.

For is there a truer reflection of a nation's inner life than the American cinema? The average American film is a slick, shallow, diverting and completely inconsequential thing. Its rhythm is that of jazz, its tempo that of the automobile and the rollercoaster, and its streaks of nostalgia and sentimentality have their ancestry in the Blues and *'Way down upon the Swanee river'*. Yet it must be reckoned with, as jazz is real and the machine is real. And because cinema has the unique property of absorbing and alchemizing the influence of inferior arts, some American films are good, and some more than good. The reason why some notable European directors have failed in Hollywood is their inability to effect a synthesis between jazz and their native European idioms. Those who have retained the integrity of their style have done better. We may mention the films of Ernst Lubitsch and Fritz Lang, and one of the very best, Renoir's *The Southerner*, which is American in content but completely French in feeling.

French films

The French cinema itself is perhaps the richest in its absorption of all that is best in French culture – in its painting and poetry, its music and literature.

One of the main reasons for this is the prevalence of avant-garde experiments in which, apart from professional film-makers, writers like André Malraux, Jacques Prévert and Jean Anouilh, painters like Fernand Léger and Man Ray, musicians like Arthur Honegger and Darius Milhaud participated. The spirit of experiment persists even in the commercial cinema, so that Jean Cocteau takes an innocuous and touching fairy tale, embellishes

it with Dadaist touches and makes of it a commercial and artistic success.

In *Monsieur Vincent*, one of the great films of our time, there is a scene which shows Vincent spending a night in a French slum in the ramshackle garret of a young man afflicted with a wasting disease. As Vincent lies in the darkness and deathly quiet of the room, snatches of neighbourhood sounds begin to seep in through the skylight – the drone of a hurdy-gurdy, the monotonous rat-tat of a handloom. The sick man begins to make wry consumptive comments which identify and illuminate each individual sound, while all the time the camera holds on the shadowy form of Vincent's head, only a gleam in his left eye showing that he is awake and alive to his surroundings. This one scene, lasting barely a minute and a half, reveals the poetry and subtlety, the humour and humanity of the best French cinema.

Possessing neither the subtlety and emotional candour of the French, nor the bravado of the American, the British cinema had to go through a particularly ignominious period until the war, and the consequent expansion of the documentary gave the needed impetus. Since then we have had films like *Brief Encounter*, *The Way Ahead* and *This Happy Breed* which have caught the national character admirably. But the fondness for half-shades and other genteel qualities we recognize as British is not exactly conducive to good cinema. Hence the frequent falling on fantasy (Michael Powell and Emeric Pressburger), on Shakespeare (Laurence Olivier), on Dickens (David Lean). At present the future well-being of the British cinema lies in the hands of a handful of directors gifted enough to overcome the ethnological handicaps.

As an extreme form of indigenous style, one may mention the early films of the Ukrainian director Alexander Dovzhenko, which were largely incomprehensible – even to Russians outside

Sergei Eisenstein
(sketch by Satyajit Ray)

their own province – not because of their language (they were silent) but because of the obscure allusions to local customs and legend. On the other hand, in the great formalist epics of Sergei Eisenstein there is a return to the broad and universal gestures of mime. Somewhere between the two extremes lies a film like *The Childhood of Maxim Gorky,* as poignantly evocative of the soul and soil of Russia as Fydor Dostoyevsky or Modest Moussorgsky.

Indian effort

But what of our own Indian cinema? Where is our national style? Where is the inspiration to transform the material of our life to the material of cinema?

Apparently, even the external truth which Renoir was striving after has not bothered our film-makers. Of our film-producing provinces, Bombay has devised a perfect formula to entice and amuse the illiterate multitude that forms the bulk of our film audiences. Bengal has no such formula, nor the technical finesse which marks the products of Bombay. But Bengal has pretensions. And the average Bengali film is not a fumbling effort. It is something worse. It is a nameless concoction devised in the firm conviction that Great Art is being fashioned. In it the arts have not fused and given birth to a new art. Rather they have remained as incongruous and clashing elements, refusing to coalesce into the stuff that is cinema. And so painting finds its expression in backdrops, music in the spasmodic injection in 'song numbers', literature in the unending rhetoric of the idealist hero, theatre in the total artificiality of acting and décor. The few freakish exceptions do not make amends and do not matter.

The pity is that there are few countries more filled with opportunities for film-making. Evidently it is the imagination to exploit these opportunities that is lacking. But there is some cause for optimism. Except in some superficial technical aspects, our films have made no progress since the first silent picture was produced thirty-five years ago, which means that there is time to learn anew and begin from the beginning.

So let us start by looking for that clump of bananas, that boat in the river and that temple on the bank. The results may be, in the words of Renoir, fantastic.

2

NOTES ON FILMING BIBHUTI BHUSAN

WHAT INSPIRED YOU to make *Pather Panchali?*

This is a question I have often been asked. The simplest and truest answer would of course be that it is one of the most filmable of all Bengali novels. But this would not satisfy those who hold that the stuff of Bibhuti Bhusan Banerjee is not the stuff of cinema. They would admit, even acclaim, the greatness of the literary original, but would say at the same time that it is not natural film material.

Bibhuti Bhusan

Amrita Bazar Patrika, 14 October 1957

Satyajit Ray directing Chunibala Devi, who played
Indir Thakrun in *Pather Panchali*

This betrays an ignorance of things filmic. One can be entirely
true to the spirit of Bibhuti Bhusan, retain a large measure of his
other characteristics – lyricism and humanism combined with a
casual narrative structure – and yet produce a legitimate work
of cinema. Indeed, it is easier with Bibhuti Bhusan than with any
other writer in Bengal. The true basis of the film style of *Pather
Panchali* is not neorealist cinema or any other school of cinema or
even any individual work of cinema, but the novel of Bibhuti
Bhusan itself.

Many have taken exception to the omissions from the novel,
but I can say with conviction that no extended work of fiction
has ever been translated to the screen without considerable

excision. It is not that no novel exists which can be filmed in its entirety. If mere recounting of incidents was involved, almost any novel could be translated. But it would be a translation faithful to the letter and not to the spirit. In order to achieve both, one needs span, space and breadth. In other words, footage.

It is a global convention that a film has to be kept within a certain length (usually the equivalent of a long short story) to qualify for commercial exploitation. As long as one accepts this convention and also expects filmed novels, one cannot be too demanding about strict adherence to the letter. Transformation, therefore, is inevitable.

Although the film of *Pather Panchali* left out much from the book, what remained so closely conformed to what people liked in the book that the omissions were largely forgiven.

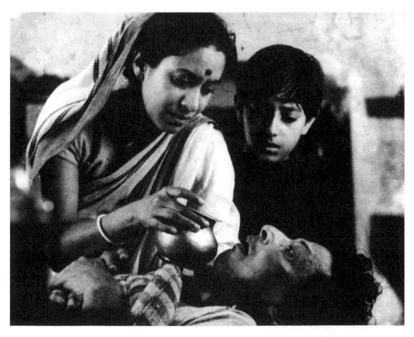

Death of Harihar (Kanu Banerjee) in *Aparajito*

The case of *Aparajito* is different. The book I consider to be a lesser work than *Pather Panchali*, although it is not by any means wholly lacking in the qualities that mark out Bibhuti Bhusan from other writers.

Why then did I choose to make a film of it? The reason is that there are two aspects of the book which fascinated me enormously.

One was the cinematic possibilities (by which I imply both visual and dramatic) of the contrast between the three main locales in the first half of the novel – Benares, a typical Bengali village, and the city of Calcutta.

The second aspect – and the more important one – was the relationship between the widowed mother and the adolescent son, intensely dramatized by a profound revelation of the author's: Apu, upon learning of his mother's death (says Bibhuti

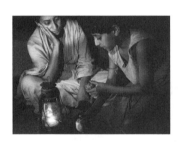

Mother and son in *Aparajito*

Bhusan), had a feeling – even if momentary – of a freedom from bondage. This would be a daring thing for anybody at any time to say, and it was the mainspring of the screenplay which, in its broad outlines, corresponds at least as closely to that particular portion of the original book as does *Pather Panchali*.

The Lila episode might have been worked into this scheme had it been feasible commercially to have made the film three quarters of an hour longer than the finished length of *Aparajito*.

A word to the critics who complained (although I myself chose to take it as a compliment) that my films often had the look of pictorial reportage: the pictorial and the documentary aspects have both been directly derived from Bibhuti Bhusan and from no one else.

3

SHOULD A FILM-MAKER
BE ORIGINAL?

ALL GREAT FILM-MAKERS
have fashioned classics out of
other people's stories.

Apur Sansar thus grew out of
situations conceived by the
author himself. I, as the
interpreter through the film
medium, exercised my right to
select, modify and arrange.
This is a right which every film-

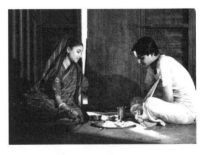

**Aparna (Sharmila Tagore) and
Apu (Soumitra Chatterjee) in**
Apur Sansar

maker, who aspires to more than doing a commercial chore – to
artistic endeavour, in fact – possesses.

He may borrow his material, but he must colour it with his
own experience of the medium. Then, and only then will the
completed film be his own, as unmistakably as Kalidasa's
Shakuntala is Kalidasa's and not Vyas's.

Filmfare, 28 August 1959

It is a demonstrable fact that a great majority of films are based on existing stories. There is nothing repugnant in this. In fact, it has two obviously admirable aspects: the writers of the stories are provided with an additional (and often unexpected) source of income; the directors have a ready-made base to start from.

Need the director, as a conscientious artist, be reluctant to use another's idea?

No, indeed, for he is in good company. Shakespeare and Kalidasa have done it in literature. Most great operas and ballets have been based on existing ideas. With the possible exception of Chaplin, who is obliged to build his plots around his own unique personality (even he, too, once used a borrowed idea in *Monsieur Verdoux*), all great film-makers have fashioned classics out of other people's stories.

Shakespeare
(sketch by Satyajit Ray)

The question may be asked: if these film-makers do not contribute an original story or an idea, what do they contribute?

Well, one may just as well ask: what did Shakespeare contribute in *Hamlet* or Kalidasa in *Shakuntala*? Or, what was the contribution of the Vaisnava poets, who had only one basic situation to write their verses on – Krishna's love for Radha?

Reduce the plot of *Anna Karenina* to its essentials, and what are we left with? The staple storyline of a thousand cheap novelettes.

And yet what is it that makes a masterpiece of *Anna Karenina*? Before one answers these questions, let us go back a little further and see what guides the film-maker in his choice of a story.

If the film-maker wants primarily to make money (a perfectly legitimate propensity), it is likely that he will turn to a bestseller. In making it into a film, his principal aim will be to stick to the letter of the original, for he realizes that the audience knows and loves the story and will brook no major deviations from the plot. The film-maker therefore puts all his energy into looking at the ultimate response: 'How wonderful! It's just like it is in the book!'

But few such slavish translations have ever made worthwhile films, and the degree to which an audience accepts such films determines the degree to which it is unaware of the purpose and scope of the true film adaptation.

Compare a good film of a book with the book itself and you will find that the original has undergone a process of thorough reshaping. The reason is simple, but needs to be stressed repeatedly: books are not primarily written to be filmed.

If they were, they would read like scenarios; and, if they were good scenarios, they would probably read badly as literature, for scenarios are no more than indications in words of what is really meant to be conveyed in images.

When I say 'reshaping', I do not mean reshaping beyond recognition. Obviously there are elements which remain unaltered or at least are recognizable. These are probably the elements which in the first place draw the film-maker to the story: some characters perhaps, or some relationships; perhaps a single strong situation or an idea, either whole or in part, noble or clever, or just provocative; perhaps a line or twist of narrative . . .

I have made a trilogy of films based on two well-known Bengali novels. The first part of the trilogy, *Pather Panchali*, was

based on the book which bears the same name. It is a great book, a classic of Bengali literature with many qualities, visual as well as emotional, which are transcribable on film. I tried to retain these qualities in the film.

Pinaki Sengupta as Apu in *Aparajito*

The second part, *Aparajito*, deals with the adolescence of the central character Apu, and is based on the last portion of the book *Pather Panchali*, and the first portion of the second novel, which is also called *Aparajito*.

As a novel, *Aparajito* is far below *Pather Panchali*. It is long-winded and diffuse, it has too many characters, and it often gets bogged down in a kind of humdrum naturalism. But the first half of it has at least one notable aspect – the profound truth of the relationship between the widowed mother and the son who grows away from her. The whole raison d'être of the scenario, as indeed of the film, was this particular poignant conflict.

The third part of the trilogy, *Apur Sansar*, which is based on the second half of the novel *Aparajito*, presented more problems. The orphan Apu was now a young man and, as depicted by the author Bibhuti Bhusan Banerjee, he charts a somewhat unclear emotional pattern.

Apu, just out of college, goes about hunting for a job; but is really more inclined towards creative pursuits. He is enamoured of one girl, but is forced to marry another. This does not produce the expected emotional crisis because Apu grows to love his wife, this

**Sarbajaya
(Karuna Banerjee)
in *Aparajito***

requiring no conscious effort on his part. The author makes no attempt to interweave these two relationships.

The wife dies in childbirth. Apu is too upset to enquire about the baby which has survived. He forsakes the child, leaves the city, and lands a job in a mofussil town. He tires of this job in a few years' time and has an urge to see his long-neglected son.

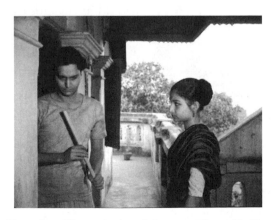

**Apu (Soumitra Chatterjee) and Aparna (Sharmila Tagore)
in *Apur Sansar***

The meeting is brief, whereupon Apu leaves the boy again, goes off to the forests of Nagpur to find peace and a job, again comes back to his son, is overwhelmed by a sudden paternal affection and decides to settle down in the city with the boy.

There is a last meeting with the first girl, when she is about to commit suicide. Apu writes a novel, earns some acclaim and, to round it off, he leaves the boy, now eight years old, in the care of friends and sets out on a vague mystical quest for peace in some unnamed region.

It is true that, in the relaxed span of the four hundred pages of the book, the events do not seem as absurdly juxtaposed as they do in my resume. But it is clear that a film of average length has no room for even a third of this material.

As a matter of fact, I concentrated mainly on two aspects. One was the relationship between the struggling intellectual Apu and his unaffected, unlettered chance-wife Aparna brought up in affluence but inspired to adjust to poverty by her love for her husband.

Apu (Soumitra Chatterjee) and Kajal (Aloke Chakraborty) in the final shot in *Apur Sansar*

The second aspect was even more exciting. Aparna dies in childbirth. A conventional writer would have made the father rush to the crib of the surviving child. Bibhuti Bhusan, who often reached for the truth below the surface, makes Apu turn against the child – he reproaches him for having caused the mother's death.

The first meeting of father and son takes place after a lapse of several years. A scenarist could scarcely want more in the way of an expressive situation.

4

THIS WORD 'TECHNIQUE'

TECHNIQUE: A MEANS to an end. The technique of warfare, of poetry, of automation. The technique of making love, of making soufflés . . . of making films.

At the turn of the century, Thomas Alva Edison invented an optical toy. In 1915, D.W. Griffith made *The Birth of a Nation*. Robert Flaherty took a primitive camera, explored the Arctic, braved its blizzards and came up with *Nanook*. This was in 1921. *The Gold Rush* came three years later and *Potemkin*, four.

If I were asked to name the six most important events of the twentieth century, the birth and the phenomenal growth of cinema would certainly be one of them.

This growth, it must be admitted, has not been solely due to the artists. The optical toy had attracted two kinds of men. One was, of course, the future film-maker who saw in it a new medium of expression. The other was the businessman, who felt that the toy would provide a lucrative opening for the show business. As happens so often, the artist had no money (and the

Seminar, May 1960

toy was an expensive one), and the businessman knew little about art. So it came to pass that the two were united for their mutual benefit and conceived the industrial act of motion pictures. The marriage has been a lasting one, and the offspring many and varied.

There are films – experimental ones, educational ones – which are not made with the intention of earning money. But these films form an infinitesimal proportion of the total world output. The vast majority of films are of the sort that we pay to see, that we love or hate or argue about, and these are the sort that have contained the best as well as the worst that cinema has provided in its fifty years of existence. These are the commercial feature films, and these are what concern us here and now.

In India, we have been making feature films for a pretty long time. The pattern of production is roughly the same as in all countries where film-making remains a private enterprise. In other words, the interdependence of film-maker and financier is taken for granted. In this set-up, we have made good films as well as bad ones. Bearing in mind that talent is a rare thing anywhere at any time, the preponderance of bad films over good ones need not alarm or surprise us. What is indeed surprising is that in spite of the protracted and precarious complexity of the film-making process, and the pitfalls that strew the path of the film-maker, good films are made at all.

Talent

Let us first see what constitutes talent in film-making. It means, firstly, a flair for the film language, and a grasp of film form. In other words, it is an ability to conceive and express ideas coherently through the medium of the motion picture camera. This, it must be explained, is quite distinct from the literary

expression of the novelist, or the dramatic expression of the playwright. It is true that the film partakes both of the novel and the play. Like a novel, it describes people, places and events and is free to move about in time and space; like a play, it deals with conflict. But, nevertheless, the purer the film language, the more independent it is of the novel and the theatre.

This language has to be learnt in the manner of all others – by a study of its use by past masters. But it is not confined only to the pages in textbooks, or even to the works of these masters. The sources of this language are all around us, in the reality that is comprehended through sight and sound, in the speech and behaviour of our fellow beings, in the throb of city life and in the calm of the village, in the flutter of an eye, in the fury of a mob and in the rhythm of the seasons.

Like the language of words and the language of music, film language too has its grammar, syntax and punctuation; its short sentences and its long ones; its pause and rhetoric and emphasis. It is only when one has learnt its grammar that one is fit to try one's hand at a full-fledged composition.

But before one proceeds any further, one has to decide upon a suitable subject. Your choice is naturally influenced, firstly, by your predilections. There are, too, some extraneous considerations that limit the field of your choice. There is the question of length. Exhibitors or the theatre owners, who are the agents through whom your film reaches the public, are quite strong in their belief that the film-going public will resent any arbitrary reduction in their weekly quota of diversion. If you make a film shorter than, say, an hour and a half, there is a good chance that it will never get shown.

Secondly, there are the codes of censorship. Touchy religious themes are taboo, and so is a too excessive preoccupation with sex.

But these are not crippling limitations. The first precludes as a possible source the short story – or at least the ones that won't bear stretching to two hours of running time – but accommodates most other subjects that are worth filming, including the Mahabharata, if one is not daunted by the prospects of a trilogy and a high cost. The second, the necessity to keep an eye on the censors, rather than causing despair, should in fact encourage subtlety of expression. It may, after all, be more fun to imply intimacy rather than to display it.

Financial backing

The choice of subject made, the next step is to find a man who would back it. This man needs to be satisfied on two counts: he must be convinced of your technical bona fides and he must feel that the story has the potential to draw a sufficiently large audience to enable the film to earn back its cost and, if possible, yield a margin of profit. Whether you succeed in finding a backer depends on a variety of factors, not the least of which is luck. But let us assume for the sake of continuing this article that you have succeeded in this vital task and are in a position to go ahead with your film.

You are now in a position to prepare a film treatment. This is the task of the scriptwriter, or the scenarist. A script, in case you don't know, is a description in words of what will eventually be conveyed through the camera and microphone. As such, the scriptwriter is expected to be pretty well up in film technique. Ideally, the director should be his own scenarist. If he is not, he should be prepared to concede part of the creative credit for the film to the writer.

The script

The script is the basis of the film, its blueprint, its skeleton. It is an indispensable first step in film-making. Griffith is said to have shot 'off the cuff' and never to have processed a script. No doubt he was blessed with an exceptional memory; in any case, he didn't have to contend with dialogue in those days. But the main difference between then and now is that in these days of hard competition, production has to be systematized for the sake of economy, and the script is a necessity as an aid to planning. Without it, or even with an inadequate script, there is bound to be fumbling and wastage in shooting. You, as a creative artist with your legitimate quota of temperament and slovenliness, may not mind it so much as your financier, who would sooner count his pennies than your foibles. And if it leads, as it must, to mundane squabbles on the set and off it, you will find that your art and your ambition, sensitive as they are,

D.W. Griffith
(sketch by Satyajit Ray)

will tend to curl up and recede into the background. A script, therefore, is a must.

Whether or not he has had a hand in the writing of it, assuming that the script is a satisfactory one and a true source of inspiration, it would be the director's job to try and extract the most out of it. He must find the visual equivalents of the verbal descriptions: the people, the places, the properties as well as the words, the music and the sounds. All these he must select and arrange to give flesh and blood and life to the bones of the scenario.

This is when the cooperative aspect of film technique really begins. You have your formidable crew of creative and enterprising technicians, the actors, the cameraman, the art director, the sound recordist, the editor, who are all paid for their services, and the validity of whose contribution is measured by the degree to which they exploit and enhance the potentialities of the subject. The actors must employ their technique of make-believe and instil conviction in the roles they are called upon to play. Since their performance is not continuous, as on the stage, but fragmentary, they would be wise to act under the guidance of the director who alone knows exactly what the bits are going to add up to.

The art director is expected to build and clothe his sets to fit the demands of the story. This calls for research as well as imagination. A room that has been lived in is as much an architectural entity as it is a reflection of the personality of its owner – and the more a background 'tells', the more expressive a film.

Other factors

The cameraman handles the one entirely indispensable tool in film-making. He lights and records the scene which the director

sets up, choosing the most effective viewpoints, always bearing in mind that the effects he creates have no existence independent of the story and that they do not serve the ends of the drama; they are merely gratuitous.

In a predominantly visual medium, the sound recordist cannot be said to contribute creatively to the same extent as the cameraman, at least not in the recording of sound, where clarity and the right dynamic level are all that he aims at. But the task of mixing the various channels of sound – of dialogue, incidental sounds and background music – is an art in itself, and a creative recordist will know and achieve the effects the director desires.

After the completion of shooting, the technique of editing is employed to assemble the separate shots into a smooth, coherent whole. In this, the editor is guided by the narrative scheme of the script as well as by his own instinctive knowledge of what makes for an effective and unobtrusive transition from shot to shot. This calls for considerable film sense and a complete grasp of the director's intentions and the story's potentialities. If the planning of the shot has been faulty, for which the blame must fall on the director, the editor is helpless to redress it. The creative aspect of editing is inherent in the script itself, in the very conception of the shots.

Perfection

It is clear that in work which requires the coordinated contribution of so many different technicians, there are opportunities for a thousand slips in execution. Perfection depends on expectation of such sustained excellence from so many individuals working under such a variety of conditions that it may well be taken as impossible of achievement. In most departments, the general level of craftsmanship in our films is

remarkably high. In spite of there being no schools of cinematography and none for dramatic training, we do not lack good actors, or good cameramen, or good recordists and editors.

What we really need is the true film artist; that dominating individual who is not only a master of his craft, but who is also aware of its social implication, of his responsibility as a possible influence on a very large and often a very naïve mass of impressionable, film-hungry individuals, who is also able to inspire and channel a diversity of talents into the best interests of work that must in the end bear the impress of his own dominating personality.

But before everything else, he must be able to acquire the right to work in creative freedom, and here he has to contend with the one man without whom he cannot do – the financier.

This freedom has to be fought for and won, and the price that the director is willing to pay for it is the measure of his integrity as an artist.

5

ALL THESE DEVICES

THERE IS SCEPTICISM among a certain class of film critics about the technical innovations that have been introduced into film-making over the last ten years or so. These critics' argument runs somewhat along these lines: 'All these new-fangled devices cannot replace true inspiration. After all, there were masterpieces made even

City Lights
(courtesy B.D. Garga)

fifty years ago. To make a Chaplin film you need a Chaplin and not a contraption . . .'

I have no intention of dismissing such notions in toto, inasmuch as I myself have scarcely been as moved by a modern film as by, say, *City Lights* or *Strike* or *The Passion of Joan of Arc*. But I do

Hindustan Standard, Puja annual, 1965

believe that while devices cannot replace imagination, they can certainly influence it and even mould it. Devices are there for the artists to use if they so wish. With them they can say new things in a new way, or even old things in a new way. Or, if they choose, they can ignore the devices and say new things in an old way, or old things in an old way.

The Passion of Joan of Arc **(courtesy B.D. Garga)**

Old masters like Chaplin, D.W. Griffith and Eisenstein aimed at a range of responses which the modern film-makers do not even feel obliged to attempt. Big, simple, rangy themes are out – consigned to limbo by the nuclear age. If a musical composer sets out to write a symphony on the Brotherhood of Man in the idiom of Beethoven, he would be looked upon as a dodo, however

talented he might be. Nostalgia for past forms and sentiments is something an artist can indulge in only at the risk of his own survival, and film artists are no different from others in this respect.

Hand in hand with the change of attitude towards themes and emotions have come the innovations in the tools. These consist of faster film emulsion, wider range of focal lengths in lenses, portable variable-intensity lights, lightweight cameras, and so on. Theoretically, it is possible to make a film today as Griffith made them by just turning one's back on everything new and sticking to the tools of the past. But a film like, say, Francois Truffaut's *Jules et Jim* – or any film by Jean-Luc Godard, for instance – could never have been made except in its own time. In fact, I doubt if the New Wave could have emerged without the advance in film technology. And it is not only the aesthetic factor we have to count, but the economic too. The New Wave directors could afford to experiment, because they could do it inexpensively, and the saving of costs has been a direct contribution of the new tools.

There are instances in all periods of cinema's history of artists feeling the need for new devices, or expressing delight at a new invention which he feels would aid him in his creative work. As early as 1912, when Griffith was making *Intolerance*, he felt that in order to shoot a scene of orgy in the Babylonian sequence effectively he wanted his camera to descend from a great height. Cranes had not been thought of in those days. But Griffith's desire for this particular effect was so great that in the end he had built a giant wheel of the carnival type alongside the Babylonian set, and put the camera on one of the carriages. The orgy commenced, the wheel rotated, and the shot was taken exactly as planned.

Writing about *Ivan the Terrible*, Sergei Eisenstein said how

lucky he was to be able to make sense of the newly invented 28mm wide-angle lens. He said this lens helped to impart to his images a monumental stylization which closely corresponded to the compositions he had sketched out on paper beforehand. When Orson Welles made *Citizen Kane* in 1941, along with the purely scenaristic problem of how to narrate different stages in the life of a tycoon, he had to face the problem of getting a ruthless realism in the images. It couldn't be obtained, he felt, with the kind of lenses and lighting cameramen used in those

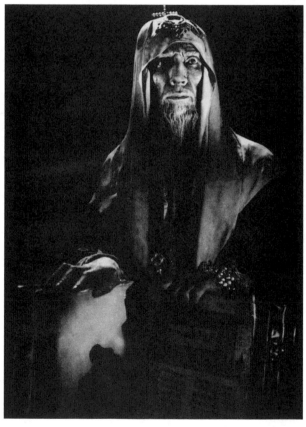

Ivan the Terrible (courtesy B.D. Garga)

days. Ultimately it was solved by means of an extremely wide-angle lens specially devised for the purpose of the film by cameraman Gregg Toland. This lens gave great depth of focus along with sharpness of detail. This, coupled with harsh lighting, produced the sort of dramatic realism which heightened the portrayal of the megalomaniac.

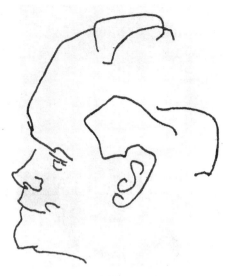

**Sergei Eisenstein
(sketch by Satyajit Ray)**

Modern technology does offer the film-maker a vast number of new devices. These can be used or misused, but in themselves they can neither be dismissed nor deplored. More often than not, they result in a saving of time and labour, although the effect achieved may not noticeably be different from those obtained with earlier cumbersome devices. Many effects, which ten years ago would need laying tracks and setting the camera up on a trolley which would need two men to push, are now achieved by the cameraman himself, shifting no more than an inch a tiny handle fixed to the body of his zoom lens.

The zoom is indeed an extremely simple and effective device in the hands of an imaginative director. And yet ten years ago the zoom was used mainly in newsreels, and there too mainly for sports coverage. Here we have the opposite phenomenon to Griffith's giant wheel: the technologist has already provided the means, but the artist doesn't immediately realize how best to use them.

6

THE CHANGING FACE
OF FILMS

CINEMA HAS UNDERGONE revolutionary changes in the last
ten years or so. Unfortunately, the new kind of films rarely
reaches the commercial screens of our country. Film societies
have a nodding acquaintance with them, but my knowledge of
them has been mainly acquired at film festivals.

Some of these changes are on the surface, and are directly
related to such things as camerawork and cutting. It is doubtful
whether such changes would have taken place but for the
introduction of new equipment, which have come into use in the
last ten years. Cameras are handier than ever before, which
means that one can use them with greater fluency. There are
now lighting equipment of such versatility and portability that
you can clamp them on to edges of tables, backs of chairs, car
doors and branches of trees. This contributes to greater ease in
shooting on location. This means that verisimilitude comes as a
matter of course.

Film World, Vol. 3, 1967

The modern film-maker has made one important discovery, namely, that a beautiful surface is not a sine qua non of great work. Music, painting and literature had long ago abandoned the pursuit of outward perfection. The film-maker has done this only sporadically, and that too only of late. Photographic conventions – born in the USA and nurtured in the USA – die hard. But modern cameramen have realized that truth may well reside in what is outwardly 'unpleasing': in the hard sunlight beating down upon ungainly dwellings, in the grey drabness of an industrial town, or even in the contours of a face racked with poverty.

Films now have a field almost as wide as literature, which is to say that almost anything that can be written can be filmed. The expansion of the area of subject matter can be said to represent the inner change that has taken place in cinema in recent times. We know about the frank treatment of human relationship in modern films. A good deal has been written against this aspect. My own feeling is that if the audience is ready for it, and if the story demands it, one can depict almost anything on the screen. One can usually tell quite easily whether a certain 'frank' scene in a film has a valid artistic reason to be there, or whether there is an ulterior, non-artistic motive behind it. The latter should be roundly condemned, and the former accepted and given due appreciation.

We, in India, are of course seriously trammelled by prejudices, social taboos, by a warped sense of what is moral and immoral in art, and by a low general appreciation caused by lack of education. It is inevitable – in view of developments abroad – that our films, even the best ones, will now seem somewhat old-fashioned to Western audiences. This is something which cannot be helped, because ultimately it is the audience which shapes a country's films, and even the more advanced section of our

audience is not free from prejudices, nor is it equipped for a trained response to contemporary art.

But this needn't dismay us. Our social conditions are such that an Indian film-maker cannot abandon certain old and accepted values. Especially in a growing, newly independent country, in a period of trial and transition, it is important, even if a little naive, to hold on to certain cherished notions of good and bad, right or wrong, morality and immorality. But this should not lead to a lack of subtlety and artistic integrity. Too much of our other arts have been devitalized and shorn of their roots by aping the West. I hope at least cinema will retain its purity and its humanness, while, at the same time, avoiding the worst fate that can befall an art form – stagnation.

7

THE QUESTION OF REALITY

JOHN GRIERSON ONCE defined the documentary as 'the creative interpretation of reality'. I have often wondered if this was not a little misleading, because the question that immediately arises from the definition is: *What is reality?* Surely it is not only what constitutes the tangible aspects of everyday existence. Subtle and complex human relationships, which many of the best fiction films deal with, are also as much a part of reality as those other aspects generally probed by documentary makers. Even fables and myths and fairy tales have their roots in reality. Krishna, Ravana, Alladin, Cinderella, Jack the Giant Killer – all have prototypes in real life. Therefore, in a sense, fables and myths are also creative interpretations of reality. In fact, all artists, in all branches of non-abstract art, are engaged in the same pursuit that Grierson has assigned exclusively to the makers of documentary films.

Let us turn to examples and take a closer look at the question of reality.

Four Times Five, 20th anniversary brochure, Films Division, 1969

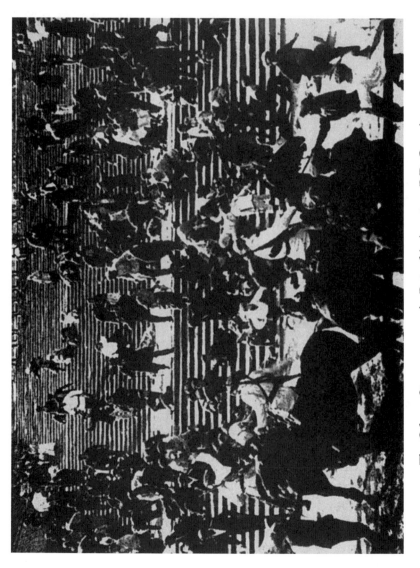

The Odessa Steps sequence in *Potemkin* (courtesy B.D. Garga)

Potemkin is ostensibly about a naval mutiny that took place in Russia in 1905. In filming it, Eisenstein took wide liberties with recorded facts. Many of the most telling details in the film are invented. The massacres by the white Cossacks didn't take place on the Odessa steps at all. So the setting of the most famous sequences in the film may be said to be fictional. Moreover, Eisenstein cast the film in the mould of the five-act Greek drama and yet, in shooting it, he used the methods of the documentary.

Is *Potemkin* fact or fiction? Or does it fall between two stools? I personally think that the film will never pass muster as a faithful account of a historical event, but as a creative interpretation of a naval mutiny it will remain a valid and artistic statement.

When Flaherty went to the South Seas Islands to make a documentary, he found that the native women had given up wearing grass skirts and had taken to cotton dresses. This clashed with his romantic preconception about the Tahitian women, and he promptly ordered grass skirts to be made for the women to wear in the film. The reality of *Moana*, therefore, is the subjective reality of Flaherty's preconception about Tahiti, and not of actual Tahitian life in Flaherty's time.

Due largely to TV, and more latterly to cinéma-vérité and other allied schools of film-making, the notion of preconception is on the way out. The thing to do now is to plunge straight into the heart of the subject. One of the common methods employed is the dogged pursuit of an individual (often a celebrity) with camera and microphone, recording his action and speech, both trite and significant. The footage is finally given some coherence by judicial selection and assemblage. The method raises obvious doubts.

Leaving aside primitive people, or people in a traumatic state or a state of extreme intoxication, it is hard to imagine anybody being in a position to completely ignore the instruments which

hover around him, recording for posterity his words and deed which are not primarily meant to be recorded. At best, he can simulate indifference. If he does it well, it proves he is a good actor. If not, he betrays a self-consciousness which gives the game away. And since acting of some sort is involved either way, the vérité aspect automatically comes under suspicion.

The face-to-face technique also presents problems. How can we ever be sure that an interviewee is making an honest statement and not merely saying what he believes is the right thing to say? To me, the really significant things that emerge from spot interviews are the details of people's behaviour and speech under the scrutiny of the camera and the microphone. Half the time I am inclined to disbelieve what they are saying, but at all times I am fascinated by how they say it.

The sharpest revelations of the truth in cinema come from the details perceived through the eyes of artists. It is the sensitive artist's subjective approach to reality that ultimately matters, and this is true as much of documentaries as of fiction films. Details can make both of them real, in the same way and to the same degree, while lack of details can turn both into dead matter in spite of all the verisimilitude that camera and microphone can impart. I like Sukhdev's *India '67*, but not for the broad percussive contrast between poverty and affluence, beauty and squalor, modernity and primitivity – however well shot and cut they may be. I like it for its details – for the black beetle that crawls along the hot sand, for the street dog that pees on the parked cycle, for the bead of perspiration that dangles on the nosetip of the begrimed musician.

8

THE CONFRONTING QUESTION

THE CINEMA OF the West today is a depressing vista on the whole. It is a cinema mainly of the youth turned cynical, heretical. Nothing is sacred any more. Conventions are there to be scoffed at, flouted. The attitude to life finds a perfect reflection in the attitude to art. In cinema, the plot and grammar and logic are thrown out of the window, and out with them go coherence, comprehensibility and conviction.

But does this not have dire consequences on film-makers? Do they promptly go out of business? Oh no, because – and this is another gift of the troubled times – taboos, too, have gone the way of all other conventions. So, to all the higgledy-piggledy confusion of forms and ideas, you add a dash of uninhibited sex, and you have what it takes to lure them in and take care of the box-office.

It is significant that the erotic scenes in these so-called 'fragmented' and 'revolutionary' films are themselves rarely

Film World, Vol. 6, No. 1, 1 February 1970

fragmented. One senses the film-maker's anxiety not to lessen their titillating impact.

Nature of medium

Part of the trouble lies in the nature of the medium itself. If you take some words at random and put them together, it becomes gibberish, and everyone who knows the meaning of words knows it as such. But if you take unrelated moving images and string them together, there will always be some people who will hold that the resultant strip of celluloid aims at some profundity. And yet the contemporary scene cries out to be filmed. It takes a Godard to do it and invest it with significance. But then Godard has cinema in his bones, and Godard can destroy in order to create, because he knows only too well what he is destroying, what he must replace it with. Also he has the detachment that no artist can do without.

There are others, such as Truffaut and Alain Resnais, who oscillate between destruction and preservation. Yet others, like Ingmar Bergman, strive for clarity within the limits of a malleable form which they stretch and mould to suit the needs of their chosen themes.

The recent series of unpleasant trends marks one of the blackest chapters in Bengal's film history. There is no point in going into sordid details. What is most saddening was that in all the bickering and shouting of slogans and slinging of mud back and forth, there was not one mention of cinema as art. The iniquities of producers, distributors and exhibitors – yes; the star system – yes; high budget and low budget, big films and small films – yes; the star system – yes; black money – yes; but not even a whisper about the fact that cinema is also an art where an artist wishes to create just as a poet wishes to write verse and a painter to paint.

One realizes today that while serious and artistic films may have been made in this part of the world from time to time, very few people – and I do not mean the public, but people connected with the making of films – think of cinema as an art.

Whither film critics?

Who is the artist catering for then? The wider public does not count where true appreciation of art is concerned. The public will go and see something that pleases it, and this does not necessarily preclude serious art. But who provides the artist the incentive to create? Not just a coterie of admiring friends, surely. What about the critics? Those on the dailies will be the first to admit that they are not always free to write what they feel about a film, and this applies to most critics on most of the daily newspapers of the world. At any rate, in the limited time and space at their disposal, they can scarcely hope to do justice to a serious work of art.

There are others on weekly or monthly magazines who are perhaps in a more favourable position. Some of them have even earned a measure of reputation. One – allegedly discerning – critic remarked apropos of my previous film, *Goopy Gyne Bagha Byne*, that it gave a clear indication of the director's striving to pander to the box-office. And this about a film that broke

Bagha (Rabi Ghosh) and Goopy (Tapen Chatterjee) in *Goopy Gyne Bagha Byne*

completely fresh ground, was based on a comparatively unknown story by an author who was certainly not Sarat Chandra Chatterjee in popularity, used no stars, cast a completely unknown artiste and another comparatively unknown in two leading roles, used songs entirely legitimately perhaps for the first time, inserted a near-abstract dance, seven minutes long, to the music of abstract and unfamiliar south-Indian percussion, and finally, provided no romance, no sentimentality, and only two females who appear for barely five minutes in the very last scene of the film. How discerning can you get?

Dreadful fears

But this is a small event compared with those that are encountered in the process of making a film. The Film Institute in Pune is at least four times as well-equipped as any studio in Calcutta, and there is no ostensible reason – unless it be sheer lack of enterprise – for this to be so. Here, while a 'shot' is being taken, one holds one's breath for fear the lights may go dim in the middle of the 'shot', either of their own accord or through a drop in the voltage; one holds one's breath while the camera rolls on the trolley lest the wheels encounter a pothole on the studio floor and wobble – thus ruining the 'shot'; one holds one's breath in fear of a crowd emerging out of the blue (we have seen this happen even in the remote jungles of Bihar), come to watch the fun (how can shooting ever be work?); one holds one's breath while the film is processed for fear of it being spoiled through sheer carelessness; one holds one's breath, too, while the film is being edited because one never knows when the ravaged moviola might turn back on the editor in revenge and rip the precious film to ribbons.

No wonder film-makers become prone to heart diseases.

9

A FILM MUST ACHIEVE
ITS OBJECTIVE

THERE IS SOMETHING incongruous about my addressing film students about to receive their diplomas. Not only did I never receive the kind of education that you have but I, for long years, looked upon film schools with scepticism. The scepticism was there even before I came into films. It was strengthened through my experience of working with people who, like myself, had never been to a film school.

When my friend Girish Karnad asked me to come and talk to the students at the convocation, I agreed mainly out of a sense of guilt. I had refused in the past, and felt the time had come to make up for my intransigence. And then I realized that I had to say something nice about schools. I tried to recall what it was that left such a wholesome impression on me the first time and the only time I had been in Pune (the Film and Television

Convocation address at the Film and Television Institute of India, Pune, published in *Commentator*, journal of the Indian Institute of Mass Communication, New Delhi, October 1974

Institute of India in Pune) some six years ago. I threw my mind back and found the answer. It was the freshness of the scene.

For the first time in my life I had been confronted with the spectacle of young boys and girls wholly wrapped up in the pursuit of films, talking them to pieces, reading and thinking and arguing about them, perhaps even dreaming about them. I found an optimism there, and an enthusiasm unsullied by the rude pressures of a ruthless industry. This was heartening. I realized that this could happen only in a film school.

The scene I was accustomed to was the one that I encountered in a film studio. Here the people had a different kind of education. Some had learnt by dint of sheer application and had worked their way up from the bottom; others had learnt from long association with established professionals. In the latter case, it was education which often had to be extracted rather than received as a matter of course. One had actually heard of professional cameramen who so jealously guarded their secrets that their assistants had a hard time finding out what camera stops were being used from shot to shot.

But at least the cameramen had some secrets to guard. And we all know that the men who handle the microphone, or build the sets and furnish them with drops, can do so only because they know the use of certain tools, and are thus in a position to pass on their knowledge to others. Experienced professional actors can, to some extent, be said to share their knowledge with less experienced amateurs when they are thrown together in the same scene.

But what about the director – the man who is supposed to be at the helm of affairs? Does he have any useful secrets to hide? What kind of education does he have? Or does he have to have any education at all?

Shocking revelation

I know this is going to shock you – especially those of you who are poised on the edge of a directorial career – but I know this for a fact that in our country at least, films have been made with virtually no contribution from the director, or at least nothing of a positive nature. He does nothing because he knows nothing.

How is it possible? The self-styled director begins by taking advantage of the fact that of the various kinds of contribution made to a film by the various kinds of people engaged in it, the contribution of the director is the least palpable. We can actually see and judge the work of actors, of cameramen, of art directors. The aural elements we can judge from the lines the actors speak, and from the way the story moves along the lines indicated in the screenplay. All these contributions can be influenced by a strong director, and shaped by him so that the overall film acquires the stamp of his personality.

To what extent he does this remains a closed book to all except those who are directly involved in the making of the film. But our self-styled director has neither the ability nor the desire to influence anything or anybody. He is only concerned with earning his bread. The moment the shooting is over, he washes his hands off the film and leaves the rest to the cutter.

One can assume that being clever he has engaged the kind of editor that will serve his purpose best – the kind that has specialized in bringing order into chaos. Doubtless he has also been clever enough to engage good assistants to take care of the continuity, to tick off the shots, and perhaps even to save him from the bother of shouting 'Action'.

At this point you may well ask: 'Why should the backer put his faith in such an ignoramus?' The answer is: He doesn't. He puts his faith in other things: in the cast of stars primarily but also in the songs, and sometimes perhaps even in the story.

What is even more alarming and must cause real despair in serious artists is that a film, made in the circumstances that I have described, by a man in utter ignorance of all that you have so assiduously learned for your diplomas, can actually have a popular success, can even earn the praises of the so-called critic, and – the final irony – may even go on to win a national award.

I wish I could say that the Institute holds the promise of changing this state of affairs. But it doesn't. What it holds is the promise of a parallel cinema – signs of which are already in evidence. This will be the cinema of young film-makers who know their jobs, who love the medium for its own sake, who are able to resist the temptations of big money and quick success, who have something to say about their own country and their own generation – something that arises out of a feeling of being rooted here, and who – however much they may have absorbed the Bressons and Godards and Antonionis – are yet aware that they have to communicate not with Frenchmen and Italians, but with their own countrymen.

Learning by experience

I have no doubt many among you have been thinking along the same lines as I am, or have already been told the same things by your teachers. Let me, however, tell you a few things from my own experience of twenty years – things which might help to fill some gaps in your knowledge. I could just as well have said *education* instead of experience, for the two go hand in hand and keep growing and growing for as long as one keeps working.

My own film education started in my schooldays in the classrooms of the public cinemas. It was later augmented by the reading of film books, and still later by the actual business of making films. The public cinemas showed what were known as commercial films. Those were films in the English language,

some British, mostly American. Interspersed between them was an occasional French or German or Soviet film. For me, in those days, the term 'commercial' held no overtones of stigma. It only helped to define an economic axiom: since a film cost a good deal of money to make, it had to be seen by a great number of people for the money to be recovered.

Some of those commercial films were good, some were bad. The bad ones were lessons in what not to do, and were just as useful as good ones. I had my definition of a bad film: it was a film which failed to achieve its objective. It follows that a good film was one which succeeded. This definition covered the full spectrum of films, from the most frivolous to the most solemn.

I did not look for a work of art every time I went to a cinema. In fact, I doubt I could have learnt very much if I had seen nothing but masterpieces. Being largely the product of that mysterious thing called inspiration, a great work of art itself remains mysterious and resists analysis beyond a certain point. Such films are more edifying and educative. The real education comes from films with strong clear lines, and not from too many hidden depths. In other words, from the work of competent professionals.

Delicate balancing

Apart from their lessons in technique, these films often revealed a delicate balancing of art and commerce which was most instructive. If the balance was at fault and the film failed, the blame was usually laid at the door of the director.

The practice of blaming the public for failing to rise to the level of the film was not in vogue those days, because the film-maker was supposed to have taken the public into account. One can draw an analogy with cooking here. When a large number of people having a meal find a certain dish unpalatable, the cook is

in no position to blame them for failing to rise to the level of his concoction. Like a meal, a film, the vast majority of films, the kind of film that will be the concern of most of you, is made with the sole purpose of being consumed. As long as it stays in the cans, a film is dead matter. It comes to life and serves its purpose only in the theatre, in the presence of the public. The public then has to be taken into account – even by you with your diplomas and your dreams of a personal cinema, a radical cinema, a political cinema, or what have you.

There is nothing instinctively wrong in the desire to make films solely for one's own pleasure, or for the pleasure of a small coterie. But in the set-ups that you are likely to find yourselves, it can be done by throwing economics out of the window. Those of you who won't be bothered with economics and are set upon a personal cinema had better start praying for generous sponsors or, more realistically, for facilities for substandard film-making. If you are truly gifted, you will sooner or later create your own market. If not, and you still want to stay in business, the only rules you would have to follow would be the rules of compromise.

But for most of you, your field of operation would be, if not within the main industry, at least in its periphery. The parallel cinema too will have to find its own market and its own audience. In these circumstances, you could afford to have your heads in the clouds only if you had your feet planted firmly on the ground. This sounds like an impossible feat, but isn't.

The history of cinema is full of instances of artistes realizing the need to communicate with a large audience, and not losing in the process. It can be done only if you temper your creative urge with a little caution and a bit of shrewdness. If this sounds unworthy of an artiste, let me tell you that even Orson Welles was not above it in his choice of subjects for his iconoclastic first film. In fact, my own choice of *Pather Panchali* was made in the

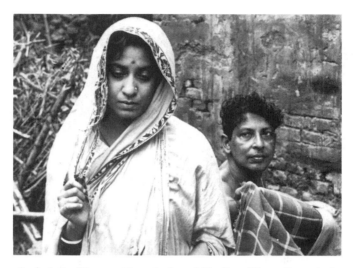

Sarbajaya (Karuna Banerjee) and Harihar (Kanu Banerjee)
in *Pather Panchali*

hope that the public interest in the film of a famous classic
would outweigh its distrust of a new director.

The idea, you see, is to get the public into the theatre. The rest
is up to the film. Remember that the public itself is a species
capable of change and evolution through pressure of circumstances.

Let me tell you in warning that with all your own learning and
all the advice that others can give you, your task will not be easy.
No school can teach you how to avoid the traps and pitfalls that
strew a film-maker's path – more so in our country than anywhere
else. Those of you who have made your diploma films must
have encountered some of them already. Multiply them a
thousand-fold, and you have some idea of what you will be up
against as a professional film-maker. What I have learned from
experience is never to lose your calm in the face of them, and to
keep pushing your convictions to the very end. Who knows, you
may yet win out. It has happened before. There is no reason why
it should not happen again.

10

THOUGHTS ON THE CAMERA

OF ALL THE arts, cinema is one which has been consistently and directly affected by advances of technology. This has naturally been most noticeable in the tools – particularly in the camera and its accessories. Think of the camera in the silent days and in the early years of sound – the huge, cumbersome, hand-cranked contraption – and compare it with the cameras of today, with their versatility and portability. Also, think of the improvements in its accessories – in lenses and filters. Add to these the improvements in film stock and it will be clear why a wider range of visual styles is available to the film-maker today than ever before.

Looking at the films of the 1920s and the 1930s today, one feels that, broadly speaking, only two kinds of visual skills were then possible in the cinema. The romantic style characterized by a luminous softness achieved with gauzes and diffusions; and the classical style, aimed at sharp, clear-cut images. Considering the

Brochure of the Society of Assistant Cinematographers, 1976

limitations of those days, we know that cameramen achieved remarkable results in these two styles.

Several technical innovations took place in the early years of sound. One, the orthochromatic film stock was replaced by the panchromatic, with its truer response to natural tones. Two, the electric motor replaced hand-cranking. Also, the bulk of the camera was reduced, leading to greater portability. Simultaneously, studio and lab facilities were enormously improved. This era also marked the development of the star system in Hollywood and elsewhere. This tended to confine the shooting in the studio and gave rise to the 'glamour' school of photography – a direct development of the romantic school of the silent days.

This state of affairs persisted, with occasional exceptions, into the late 1940s, when a fresh spate of technical innovations – mainly brought on by the World War II – made its impact felt in cinema. In the last twenty-five years, thanks to rapid advances in technology, the film medium has achieved unparalleled flexibility in the West as well as the Far East. Film-makers – aided by their cameramen – have used this flexibility to enlarge their vocabulary, and thus enrich the medium itself. Most major film-makers today are recognizable as much by their personal feelings and social attitudes as by the photographic texture of their films. The classical style has come back, and with it has come a whole range of subsidiary styles.

Although it may sound paradoxical, the movie camera has actually grown younger with age. The cameraman today is a person who must constantly explore and recharge his batteries. Also, he must be prepared to discard old prejudices, and apply a fresh mind to his problems – provided, of course, that the director himself has new things to say in a new way.

11

'I WISH I COULD HAVE SHOWN THEM TO YOU'

ONE OF MY very few recollections of the Indian silent cinema consists of a brief moment from a Bengali film called *Kaal Parinaya* (*The Doomed Marriage*). The hero and the heroine – or was it the vamp? – newly married, were in bed, and a close-up showed the woman's leg rubbing against the man's. I was nine then, but old enough to realize that I had strayed into forbidden territory. The visit, need I say, to this early example of Indian soft porn was accidental. An uncle of mine had taken me to the Globe to see the first Johnny Weissmuller Tarzan film. Going to the bioscope in those days being a rare and breathlessly awaited event, it was heartbreaking to learn that there were no seats to be had. Obviously touched by the sign of dismay on my face, my uncle took me walking four hundred yards to the Albion to see *Kaal Parinaya* instead. I still remember his growing discomfiture as the risqué drama unfolded, and his urgent and periodic 'let's go home' being met with a stony silence.

Cinema Vision, January 1980

The cinema we loved to go to then was the Madan, where the mellifluous tones of the Wurlitzer organ drowned the noise of the projector while heightening the drama on the screen. The Globe was nice too. It didn't have an organ, but it had turns on the stage during the intermission. Both the Globe and the Madan showed first-run foreign films, as did the Elphinstone, the Picture Palace and the Empire. They all stood clustered at the heart of Calcutta's filmland, exuded swank and boasted an elite clientele.

On the other hand, the cinemas showing Indian films, such as the Albion, were dank and seedy. One pinched one's nose as one hurried past the toilet in the lobby into the auditorium and sat on hard, creaky wooden seats. The films they showed, we were told by our elders, were not suitable for us. Since the elders always decided what we should see, the choice inevitably fell on foreign films, usually American. We thus grew up on a wholesome diet of Chaplin, Buster Keaton, Harold Lloyd,

Dadasaheb Phalke
(courtesy B.D. Garga)

Douglas Fairbanks, Tom Mix and Tarzan, with an occasional drama-with-a-moral like *Uncle Tom's Cabin* thrown in.

Years later, when we opened our film society with a classic of the silent cinema, *Potemkin*, it struck us that we ought to explore the area of our silent period. We knew it had a long and lusty life ever since Dadasaheb Phalke and *Harishchandra*; we knew the names of films and filmmakers, but we didn't know

the films. The stills in movie magazines of that period suggested a preponderance of mythologicals, with a sprinkling of social dramas usually based on popular novels. Both the Chatterjees – Sarat Chandra and Bankim Chandra – were staples. The heroes were as lavish in their use of make-up as the heroines, the décor was straight out of popular theatre, and even in a frozen state one could see that the style of acting was distinctly larger than life.

Sometimes one found these elements in foreign films too. Theda Bara could well have fitted into a Bengali drama of dark passions, and I recall much flaring of nostrils by villains in sundry Hollywood films. And yet I know that the best of American and European cinema of the silent period was accessible to our film-makers. I once went to the National Library to look up old newspaper files just to find out what kind of films were being shown to our audiences in the 1920s. Running my eyes over the amusement column of *The Statesman* of a certain date in 1927, I found that the filmgoers of Calcutta had a choice of six foreign films, all playing at the same time. They were *Moana*, *Variety*, *The Gold Rush*, *Underworld*, *The Freshman* and *The Black Pirate*.

Did such films have any discernible influence on our film-makers? Was there, for instance, an Indian Griffith trying to grapple with the problems of a brand-new art form, the only one to have evolved in the historical period? Was there an Indian theorist like Eisenstein, a poet like Dovzhenko or Robert Flaherty, an Ernst Lubitsch exploring the possibilities of visual comedy?

For me, the questions have remained unanswered. We looked for prints of Bengali silent films and drew a blank. All such prints, we were told, had been destroyed sometime in the 1940s in two fires in two of the biggest film vaults in Calcutta. They were on inflammable stock, and no one – no director, producer,

distributor or exhibitor – had ever thought to replace any of them with modern stock. The conclusion was inescapable: the talkies had come and wiped out all interest in the earlier medium.

But we did not give up. We continued our search and finally came up with a lone print of a 1930 version of Bankim Chandra Chatterjee's *Krishnakanter Will*. How this one had survived the holocaust no one could tell. We screened the film and watched it unreel with bated breath. If only we could discover one tiny spark of imagination, a genuinely felt moment that would stand out and proclaim the artist!

The deflation, as it happened, was rapid and total. But for an occasional sortie out of doors, the entire film was confined to three or four three-walled roofless sets, the camera perched in the middle at a safe distance from the action, while the characters flitted in and out of impossible wing-like doors at the two extremities. Without a plethora of titles to tell the story, it would be impossible for someone not familiar with the plot to make out who was who and what they were doing and why.

A Throw of Dice
(courtesy B.D. Garga)

And yet I knew there were exceptions. For instance, some of the stills I had seen from the film of the actor-director-art director Charu Roy (he is the swarthy hero who kisses Sita Devi smack on the lips in *A Throw of Dice*) suggested a much more sophisticated approach. One can see the performers used less obtrusive make-up, the props show a discernment in their choice and placing, the lighting lends an air of credibility. In other words, a decided penchant for realism. Charu Roy was in his eighties when I met him for

the first time. I asked him about his films. 'I wish I could have shown them to you' was all he said.

On another occasion, sometime after I had made *Pather Panchali,* I met Profullo Roy, younger brother of Charu. Profullo started as a director in the silent period, made the transition to sound and continued to work until a resounding flop in the 1950s ended his career. A hefty man with a loud, grating voice, he was known to have been a dictator on the set. Ramrod straight at seventy-five, he gave me a hearty slap on the back and said, 'You know, I shot a whole film on location thirty years before you did!' He was naturally unable to show the film because no prints existed. But the stills – it was a cops-and-robbers yarn – do seem to bear out his claim of location shooting.

It is truly tragic that the history of the silent films of one of the main film-producing centres in India must remain in limbo forever. One dearly hopes that this does not apply elsewhere, that it is still possible to reassess the work of, say, the pioneering Maharastrians. How wonderful it is to be able to see today, fifty years after it was made, a print of *A Throw of Dice* that looks as if it was shot yesterday on the finest grained panchromatic stock! That the story is a cross between *A Thousand and One Nights* and the Mahabharata is beside the point. What is important is that the people involved in its making, Indians and Germans, realized the need for preservation, which makes it possible for us to see it now in its historical perspective.

Interest in silent films has grown enormously in recent years. They are now seen not as the tadpole stage of what eventually grew into a frog but as a fully developed species in its own right. Exploration into the silent period in Japan has yielded unexpected riches. Should such mute treasures lie hidden away in the vaults of our country too, it is our business to track them down and bring them to light.

12

THE NEW CINEMA
AND I

WITH THE EMERGENCE of a crop of gifted film-makers in the country in the last eight years, it is certainly legitimate now to talk of a new Indian cinema. What sets these film-makers apart from the commercial 'All India' ones is a preoccupation with serious, rooted subjects which are put across with an imaginative use of modest resources.

Many of these film haven't come my way yet, but of the ones that I have seen, those from the south – *Samskara, Kaadu, Nirmalayam, Chomana Dudi, Ghatashraddha, Kodiyettom, Thampu* – all deal with rural themes. This distinguishes them from the new cinema of other regions where the stress is more urban. For instance, *22 June 1897*, made by the husband-and-wife team of Chinu and Jayoo Patwardhan, is concerned with an actual political murder in Poona in Tilak's time, while Govind Nihalani's *Aakrosh* depicts a present-day situation where a young lawyer investigates the murder of an adivasi girl. Saeed Mirza in

Samskara (courtesy NFAI, Pune)

Bombay and Buddhadeb Dasgupta in Bengal both show a preference for contemporary urban themes. I have yet to see the first films, well spoken of, by Muzaffar Ali, Biplab Roy Choudhury and Sai Paranjpye. At least a dozen names where almost none was heard ten years ago. Admittedly, therefore, a trend, and a welcome one.

It is necessary to point out that none of these films are new in the sense of being innovative in the use of narrative methods, as Mani Kaul's films are. This may be a good thing in view of the kind of public we have to contend with. A trend that is marked by an overt preoccupation with idiom and form rather than with content may have problems of communication, and therefore, of survival. Where the vast majority of films bypass reality altogether and pander to the lowest common denominator, any effort that spurns these tendencies comes as a radical departure, and is to be applauded.

Unfortunately, such films are apt to run into trouble when the question of bringing them to market arises. Many of the ones I have mentioned above have only been shown privately and at film festivals. Even prize-winners like *Shodh, Sparsh* and *Neem Annapurna* are languishing for lack of theatres willing to play them. Exhibitors as a rule are not prepared to take risks with offbeat films. This is where the government must lend a hand and provide outlets. The new directors must find out how the audience reacts to their work. If communication is the aim, it has to work with the paying public. The biggest boost for a film-maker comes not from critical praise or the praise of a small coterie or from a festival prize; it comes from the acceptance of the film by the public for whom it was made.

Aakrosh **(courtesy NFAI, Pune)**

Since even a low-budget film costs far more than, say, an ambitious enterprise in the theatre (which uses, like film, multiple creative resources), reducing the cost of production assumes major importance. That is why switching over to 16mm will substantially help. As *Aakrosh* has proved recently, we now have the technical resources to make blow-ups of a quality that wipes out any discernible difference between 16mm and 35mm. Whatever the government can do to facilitate production in the substandard gauge will be most welcome.

I strongly believe that regional films should be made as far as possible in the language of the region. This seems to be the general practice in the south. The inevitable corollary to this is that the film-makers have to be content with a smaller market. Some expansion of this market at home is possible through the use of English subtitles, or by dubbing in Hindi. The first would involve either foreign exchange for subtitling abroad which the government must be prepared to grant, or introduction of facilities for high-quality subtitling at home which don't exist now, and which it is high time the government did something about. Dubbing, to me, is a far less satisfying method aesthetically, but may have to be resorted to where a film aims to reach a wider audience than just the urban one.

With the growing interest in Indian art in the West, the really noteworthy new Indian films are sooner or later likely to find a market abroad. This would provide a genuine incentive while reducing the economic hazards.

I sincerely believe that I could not have survived as a film-maker but for the success of my first film in the West. Ever since, a good part of the takings on most of my films have come from abroad. This is a slow process and can't be compared with the smashing box-office successes at home where costs are covered in a matter of weeks. So strong and widespread is the hold of the

ineluctable conventions of commercial cinema on the public that any film-maker who ignores them has also to abandon hope of quick success. I am convinced that it was the irresistible human appeal of *Pather Panchali* which made it work with all classes of audience in spite of the absence of conventional claptrap.

I fully believed that I was making something new, even innovative, for India when I made *Pather Panchali*. In fact, the main incentive for me was provided by the insipid, hidebound, hybrid nature of Bengali films, which had discovered early on what the audience wanted, and stayed resolutely on the safe path. The field was vast and fertile, themes and stories cried out for filming, and yet what was being produced was neither wholesome nor even truly indigenous. It is generally believed that Bengal led the field in the 1930s and 1940s. I've looked and found no evidence to support this belief. It is true that Bengal, of all states, had the richest fund of literary material to draw upon. Much of this material was in fact being used. Sarat Chandra, widely translated and admired, was a gold mine, and was filmed again and again. The pallor of these adaptations has to be seen to be believed. Despite this, I believe that the credibility of Sarat Chandra's characters and the simple, affecting quality of the stories had much to do with putting Bengal in the forefront.

The practice of injecting songs in every kind of film in every kind of situation had presumably evolved simultaneously in all the three major film-producing centres in the country with the coming of sound. But because Bengal showed a propensity to making films around social themes, the arbitrary inclusion of songs struck a far more jarring note than, for instance, in films from Madras which were openly outlandish and escapist. Looking at Debaki Bose's *Chandidas* and *Vidyapati* now – dated to the point of embarrassment – it is difficult to see why they were once so highly regarded. And yet a film like *Ramshastri*,

made some years later, still retains much of its freshness. My own feeling is that Maharashtra had caught up with and surpassed Bengal fairly early in the period of sound. Barring the technical contribution of the Bose brothers, Nitin (camera) and Mukul (sound), and the countrywide popularity of New Theatres' Hindi films, there is nothing to substantiate Bengal's claim of pre-eminence.

Vidyapati (courtesy B.D. Garga)

In the 1940s, two major novelists of Bengal took to directing films from their own stories. They were Premendra Mitra and Sailajananda Mukherjee. Unfortunately, they too appeared to share the common belief that cinema was a popular medium which debarred seriousness of approach. Or else why did they bypass their own best stories and go in for popular concoctions? The occasional sophistication of plot and characterization that crept into their work by virtue of their being sensitive writers

was subverted by an inept use of the technical resources of cinema.

New Theatres' 1943 production of Bimal Roy's *Udayer Pathe* (*Hamrahi* in Hindi) was widely regarded in its time as a milestone in Indian cinema. Timely in its theme, bold in its use of unknown amateurs in leading roles, and admirable in its moral stance, it was a step in the right direction, though not a big one. The film worked because Bimal Roy was a fine technician with a surer grasp of narrative than most directors. It had the usual concomitant of songs, the sets smacked too much of the studio, and the dialogue was too pat and polished to ring true. Even *Do Bigha Zameen*, Bimal Roy's best film and the best Indian film produced till then, was compromised by a melodramatic ending, and Russian-sounding choruses sung by Bihari peasants.

Do Bigha Zameen
(courtesy B.D. Garga)

Against this background, *Pather Panchali* couldn't but stand out as something new for its negative virtues alone. The fact that it was well received at home gave me the necessary push to venture into fields as yet unexplored by our film-makers.

Over the years, I have moved from genre to genre and covered a wide range of subjects. If my output appears too diverse, it only reflects my varied preoccupations, and my anxiety not to fall into a rut. I can honestly say that with only one exception – *Chiriakhana* – I have never taken up a subject that didn't interest me deeply. I was conscious of breaking new grounds thematically

Uttam Kumar as detective Byomkesh in *Chiriakhana*

Manisa (Alaknanda Roy) and Ashok
(Arun Mukherjee) in *Kanchenjungha*

Dayamoyee (Sharmila Tagore) and Umaprosad (Soumitra Chatterjee)
in *Devi*

Biswambhar Roy (Chhabi Biswas) in *Jalsaghar*

with films like *Devi, Jalsaghar, Mahanagar, Pratidwandi, Seemabaddha, Jana Aranya*. I believe that the narrative methods in films like *Charulata, Kanchenjungha, Aranyer Din Ratri, Shatranj Ke Khilari* are far from conventional.

If I were asked what has been my main preoccupation as a film-maker, I should say it has been to find out ways of investing a story with organic cohesion, and filling it with detailed and truthful observation of human behaviour and relationships in a given milieu and a given set of events, avoiding stereotypes and stock situations, and sustaining interest visually, aurally, and emotionally by a judicious use of the human and technical resources at one's disposal. I know this sounds pompous and involved, but I can't think of any other way to put it. I find this an absorbing, inexhaustible and by no means easy task that I intend to pursue as long as I keep making films. My best achievements as a film-maker lie within this field of pursuit. I am aware that they are not of a kind that hits one in the solar plexus, which is why they may well have been missed by many critics and most filmgoers here (I have not often been praised or blamed for the right reasons). I should point out that when I say 'here', I mean my own state of West Bengal. Outside it, in the rest of India, where even in the major cities my films are either never shown or shown surreptitiously on Sunday mornings, generally without subtitles, I am only a name, and have been one for all of twenty-five years. It certainly gives one an odd feeling.

13

UNDER WESTERN EYES

WHEN I WAS halfway through the shooting of *Pather Panchali*, Monroe Wheeler of the Museum of Modern Art, New York, came to Calcutta to collect material for an exhibition of Indian art. Our shooting was held up for lack of funds – not for the first time – and I was back at my advertising job. I had an arrangement with my firm whereby I could take time off for shooting when we had money, and be back at my desk when the money ran out. Wheeler came to our office. He had heard I was at work on a film, and asked to see stills. I showed him a dozen or so. 'Do you think you could let us have this film for our exhibition?' he asked. 'That's a year from now.'

I could hardly believe my ears. The one thing that had kept me from throwing up my hands and calling off the whole project in spite of repeated and massive setbacks was the hope that my film would one day reach a Western audience. Now it seemed I was going to gain my objective far sooner than I had any right to expect.

Sight & Sound, 50th Anniversary issue, Autumn 1982

Satyajit Ray waiting for the right weather during the shooting
of *Pather Panchali*

Satyajit Ray at Boral village during the making of *Pather Panchali*

But why was it so important to reach a Western audience? Simply because, given the higher standard of films in the West (one didn't know the Japanese cinema yet), one expected a higher level of appreciation to go with it. All the world knew that India turned out a vast number of films with a lot of singing and dancing in them. The fact that fat books of film history gave only half a page to this champion consumer of celluloid was not surprising, since few Indian films ever reached the West where such books were written.

About ten per cent of India's output came from Bengal, where I worked. Bengal had a small market and a large pride in its literary tradition. It didn't make song-and-dance movies; it made tame, torpid versions of popular Bengali novels for an audience whom years of cinematic spoon-feeding had reduced to a state of unredeemable vacuity. The urban intelligentsia had access to foreign films, mostly American, and therefore could claim to be more perceptive. But they were too small in number for the serious film-maker to bank on. As for critics, what passed for film criticism in India usually consisted of a tortuous recounting of a film's plot, followed by a random dispersal of praise or blame on the people concerned in its making. Neither the film-makers nor the public took much heed of it.

What was also regrettable was the insidious notion, probably concocted by the same critics, that cinema being a product of the technological West, our own efforts should not be judged in too harsh a light. After all, ran the argument, the West had all the money and all the resources; we didn't.

The fact is, film-makers the world over used the same tools, the same technology. The rules of the cottage industry simply didn't apply. One could spin yarn at home by turning a wheel, but to spin the simplest yarn on celluloid the wheels of a large-scale, fully fledged industry had to turn. We didn't lack resources.

We had tools and actors and craftsmen aplenty. We had, yes, a literary tradition. So we had stories, and we had themes to turn into stories. What we lacked were the faculties of mind to make the best use of what we had.

This is what had to be proved. It was high time Indian cinema came of age, and high time it came out of its self-imposed seclusion to be measured by the standards of the West. Six months after Monroe Wheeler's visit came John Huston. Huston was in India to look into the possibilities of filming *The Man Who Would Be King*. Wheeler, whom he knew well, had asked him to enquire on the state of my film and, if possible, to take a look at some of the footage. Doubtless he was anxious to know from an expert if his hunch had paid off.

I showed Huston ten minutes of silent rough cut, choosing the passage where Apu and Durga have their first sight of the train. 'A fine, sincere piece of film-making,' was Huston's comment. But he warned me against showing long stretches of aimless wandering, which is what the two children do before they happen upon the train. 'The audience gets restive,' he added. 'They don't like to be kept waiting too long before something happens.' But he gave a good report to Wheeler.

The effort to catch the Museum's deadline took on epic proportions, and my editor and I were done up to a frazzle by the end. But we made it, just. The Museum had rightly announced the screening as the world premiere of the film. There was to be a handpicked audience including, I was told, the Gish sisters. The print had no subtitles, and I had no opportunity to take a look at it before sending it. I believed I had made a good film, but while I waited for word from the Museum, doubts began to creep into my mind. Why should a Western audience care for a downbeat tale of poverty in a remote Indian village? In the total absence of familiarity – with the people, the place, the problems,

the language – how could the audience be involved? And without involvement, how could the film work? Has any Indian film ever worked with a Western audience – especially one that eschewed all the trappings of the exotic? No tigers, no maharajahs, no fakirs, no snake charmers, no nautch girls . . .

The more I pondered, the more I realized how hopeless it was. There was nothing to suggest that, outside the field of specialization, the West took the slightest interest in India. The Taj Mahal drew the tourists, of course, as did the burning dead on the ghats at Benares. But there it ended. A vast subcontinent with one of the oldest and richest traditions of art, music and literature existed only to be ignored.

That this apathy should apply as much to Britain, which once ruled India, as to any other Western country is astonishing, but true. The fact is, the colonized have, willy-nilly, developed considerable interest in the colonizers, never the other way round. There are exceptions to this, of course. Both in the days of the East India Company and during the Raj, travellers, civil servants, soldiers, missionaries and others had recorded their impressions of India. Some of these memoirs reveal a genuine insight into the country and its people. Travelling in slow stages by boat, buggy and palanquin brought these sojourners into close touch with life in the countryside, until the railways brought in speed and privacy. Such accounts, both in words and pictures, were often a reflection of personal enthusiasm combined with pride in the Empire. To what extent such enthusiasm infected the dwellers in the Island, and how much of the information provided by the memoirs seeped into their consciousness, is debatable. At any rate, barring students of Indian social history, who reads such memoirs now? How many know the paintings and aquatints of Zoffany, D'oyly, Hodges, the Daniell brothers?

Against the British schoolboy's knowledge of Indian history,

however fragmentary and biased, must be placed such grotesque stereotypes as Hurree Jamset Ram Singh of the fourth form at Greyfriars. Here, in the pages of the weekly that was once every British schoolboy's gospel, is H.J.R.S. ('Inky') holding forth: 'The rowfulness is not the proper caper, my esteemed Bob . . . Let dogs delight in the barkfulness and bitefulness, but the soft answer is the cracked pitcher that goes longest to a bird in the bush, as the English proverb remarks.'

Late Victorian and Edwardian novelists sometimes used the more exotic and sinister aspects of India in what were basically stories of mystery and adventure. The most famous example is of course *The Moonstone*. Indeed, the jewel in the forehead of the many-armed Hindu idol had a remarkably long and sturdy existence. It kept cropping up in tales of adventure till well into the Georgian era. Both Conan Doyle and Jules Verne turned more than once to India for inspiration. It was an Andamanese poison-dart that killed Bartholomew Sholto in *The Sign of Four*, and Captain Nemo turned out to be an ex-maharajah whose kingdom had been usurped by the British. These stories and others in the same genre, read far more avidly than the factual accounts, shed no more light on India than Hurree Jamset Ram Singh. There might have been some hope had a large body of Indian literature been available to the West in translation. It has never been so. Tagore had a brief vogue in the West early in this century, the brevity being a direct consequence of the inadequacy of the translations. The handful of Indian writers who write in English and are read and admired in the West, such as R.K. Narayan, do illuminate certain aspects of India, but not enough to dispel the widespread ignorance. How else to explain a major writer like Paul Scott getting so many of his Indian names wrong? Mr Subhas Chand Gupta Sen, the north Indian, in *The Jewel in the Crown*, is about as convincing as Mr Gottfried

DonaldMac, the Frenchman; and Darwaza Singh in the same novel would translate perfectly as Mr Front Door Smith. What is distressing is the way such gaffes are flung in the face of the reader, as if getting the facts right about India is of the least concern to a Western writer. The one writer who gets his Indian details consistently right is H.R.F. Keating, in his Inspector Ghote novels. But who expects profound insights into a country and its people from detective stories, good as they may be?

Certainly the most sensitive novel about India by an Englishman is *A Passage to India*. But even Forster had no access to large areas of the Indian mind. There is a scene in the tennis club between two Englishwomen, Mrs Moore and Miss Quested, and a Bengali couple, anxious to 'know' India. Mrs Moore suggests that they call on the Bengalis someday. The latter readily agree and promise to send their carriage to pick them up 'on Thursday morning'. Thursday comes but the carriage never arrives. The English ladies conclude that they must have made some stupid blunder and caused offence.

The incident has the kind of plausibility that suggests Forster himself may have had the same experience and felt just as nonplussed as Mrs Moore and Miss Quested. And yet for an Indian there is no mystery here. It is a typical Anglo-Indian situation which turns on the problem of language. The conversation between the three ladies suggests that Mrs Bhattacharji's command of English is at best rudimentary. If the English ladies did call, she, as the hostess, would have to contribute in a large measure to the conversation. The prospect being too unnerving, the Bhattacharjis never meant to send the carriage in the first place. And yet they said they would because not to have done so would have called for excuses and more groping for words. The choice here was between seeming discourteous and seeming stupid. An easy choice for an Indian

in British India, since the first was more likely to put an end to such embarrassments as far as these two memsahibs were concerned.

Kipling, writing about Indians, often gets closer to the truth than any Western writers before or since. *The Miracle of Purun Bhagat* could well be the work of a particularly gifted Indian writer, and Hurree Chunder Mookerjee is the nearest the West has come to portraying a Bengali in fiction whose babuisms ring true. The beautiful Mowgli stories have served as typical Indian fables in the absence of genuine fables and folk tales which, though translated, never took roots in the West as did, say, Ali Baba, Sinbad and Aladdin.

And yet Kipling's stories could hardly be expected to unravel all the mysteries. India is too vast, too complex, too multilayered for one writer, or half-a-dozen or a dozen writers to cope with. The Indian's knowledge of the English is based not on a handful of books, but a whole spectrum ranging from comics and penny dreadfuls to Shakespeare and the classics. The study of English had been imposed from the top as an imperialist policy. While serving functional and academic ends, it grew in many cases to a pursuit for its own sake. More often than not this pursuit took place without any actual contact with the British, who were not only unapproachable but virtually invisible to the average Indian. The closest that he got to an Englishman was the Tommy on his charger swinging his baton over a cowering Indian football crowd. But the important thing is that the fact of imperialism with all its implications never got in the way of this study of English that opened the door to an alien culture.

Learning about Britain from books had its hazards, though. I read P.G. Wodehouse as a schoolboy and came to believe that most homes in England employed butlers, while the Sherlock Holmes stories conjured up a London perpetually shrouded in

impenetrable fog. (In my thirty-odd visits to that city I have not once encountered the London fog.) It took many years and much reading for the jigsaw pieces to begin to fit and a picture to emerge that came close to the reality.

There was no way the English could get so close to India. Not even in India. There was some intercourse between the rulers and the ruled in the early days of the Company when the English smoked hookahs, gave nautch parties and spoke Indian languages. The British civilian then had to learn an Indian language before he stepped on the soil of India. All this changed slowly through the nineteenth century till the trouble over the sepoys drove a wedge between the two communities and put an end to all socializing. 'Knowing' India was henceforth confined to well-meaning visitors like Mrs Moore and Miss Quested. Till Independence caused an exodus, the British simply lived here, having fashioned a world where they could pursue their native habits. A home away from home. Away from their Island, but insular still.

If such were the Britons in India, what hope that those back home would be otherwise? Or the rest of the Western world, free from proximity to this alien culture, free from any compulsion to come to grips with it? The upshot was that, the effort of memoirists, Indologists and historians notwithstanding, India remained a nebulous entity to the West; a vast amorphism that refused to take on a semblance of the familiar.

The few films about India from the West only helped to strengthen this feeling. The emphasis was on the westerners; the few Indians merely flitted about, lent colour, and conformed to stereotypes. In Ramon Novarro's *Son of India*, a Hindu Brahmin sporting a Sikh turban and bearing the Muslim name of Karim may be a spectre from the dim past, but what about the suave Brahmin Mr Bannerji in *The Rains Came*, getting down on his

knees and intoning gibberish with folded palms to appease the Rain God? The Peter Sellers brand of Indian, though played with subtle relish, is really an extension of Hurree Jamset Ram Singh, good for a laugh and not much else. And once again, as in the novels, the ignorance is brazenly flaunted. For a land where cows are holy and God is a phallus, anything will pass for the truth.

The sights and sounds and moods of India, or rather, the Bengal riverside, were caught beautifully by Renoir in *The River*. But this too was primarily a story of Britons in India. The presence of a GI would date the story around the mid-1940s, a period of considerable political unrest. But Renoir's placid, poetic approach, and the script by Rumer Godden and Renoir, bar the intrusion of such elements. As a result, an air of fairytale unreality pervades the whole film, and robs it of value as a social document.

My apprehensions about *Pather Panchali* were proved wrong. Although the first cable from Monroe Wheeler saying 'a triumph of sensitive photography' only confirmed my doubts, a letter – not from Wheeler – which soon followed assured me at length that the film had gone down well at the Museum.

In September 1958, I was in the lobby of the Fifth Avenue Playhouse in New York where *Pather Panchali* had its US premiere. I watched the audience surge out of the theatre bleary-eyed and visibly shaken. An hour or so later, in the small hours, came the morning edition of the *New York Times*. It carried Bosley Crowther's review of my film. Crowther was the doyen of New York critics, with power to make or mar a film's prospects as a saleable commodity. Crowther was unmoved by *Pather Panchali*. In fact, he said the film was so amateurish that 'it would barely pass for a rough cut in Hollywood'. Later, he had second thoughts as letters poured in to say how wrong he was. The film ran for eight months.

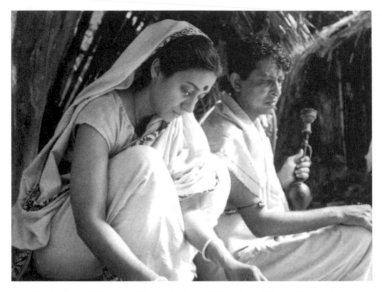

Sarbajaya (Karuna Banerjee) and Harihar (Kanu Banerjee)
in *Pather Panchali*

And yet I know Crowther was not wholly wrong. Judged on the level of craftsmanship, there was much that was wrong with my film. It couldn't be otherwise. We shot it in sequence, learning as we went along. The early part clearly shows we were groping with the medium. Shots are held for too long, cuts come at wrong points, the pace falters, the camera is not always placed in the right position. The second half is much more assured and – this is what was probably behind the film's wide success – works well on an emotional level, even with a Western audience.

How does this success square with the fact that the Western audience, barring a few stray exceptions, knew nothing about India and probably cared even less? What is the first thing a Western viewer tries to perceive in a film? For that matter, what does anyone try to perceive in any film? The story, of course. Everyone everywhere understands a story. It is a trait common to all cultures – from the Eskimo to the Hottentot. What in its

bare bone is the story of *Pather Panchali*? A poor family fights a losing battle against adversity, leaves hearth and home to set off towards an uncertain future. A simple, universal situation holding in its implication of conflict the promise of a screenplay.

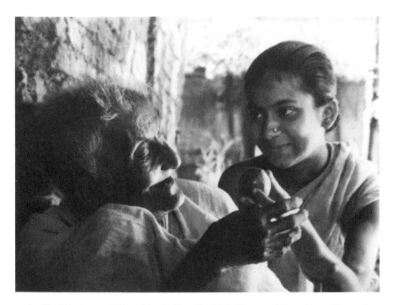

Indir Thakrun (Chunibala Devi) with Durga (Uma Das Gupta) in *Pather Panchali*

The novel *Pather Panchali* was a sprawling saga whose leisurely, episodic unfolding perfectly caught the rhythm and pace of life in a Bengal village. In this it had wholly departed from the terseness of the earliest nineteenth-century Bengali novels which were inspired by European models. In adapting it, I tried to combine the relaxed quality of the original with a tightness called for by the exigencies of the conventional feature film. Incidents had to be discarded and shuffled around, characters dropped (the original had over three hundred, the film thirty), and the story made to progress along a curve that rose and fell in

a succession of contrasted episodes. Contrast was important in the absence of a tight dramatic structure. Also, to give the film the semblance of a story, I introduced the element of causality. In the novel, the two deaths – old Auntie's and Durga's – are shown as unrelated by causal links to anything that precedes them. In the film, Auntie's death can be seen as a consequence of her sister-in-law's cruelty, while Durga dies from pneumonia caused by her ecstatic surrender to the monsoon shower. And so on. The outline that emerged was simple enough as a story to be comprehensible at all levels.

Next was the stage of fleshing out. The familiar lineaments were now given an overlay of details – of speech, behaviour, habits, customs, rituals – which placed the story in a specific time and place within a specific culture. This was further strengthened by shooting on actual locations and using an unadorned style of photography.

Since with all its details the film had a simple structure, a Western viewer could keep his bearings by holding on to the basic story and relationships, while a host of new information, new impressions played upon his consciousness, dislodging or reinforcing preconceived notions, arousing by turns his interest and apathy, surprise, conviction and disbelief. What will the ill Auntie do with that dried-up coconut leaf she's just dragged in? What is Durga doing squatting on the ground before a sapling, reciting what sounds like doggerel? What does that four-armed idol with an elephant's head stand for? A brass band playing 'Tipperary' at a village wedding in Bengal? How droll!

If in this welter of impressions his sympathy is aroused, the film will work for him, certainly as a story he believes in, and also, if he is able to respond to those qualities which make a film a film, as a work of art.

Of course, there are obvious risks in exposing an audience to a

wholly alien culture. There was an American lady, for instance, who was so upset by the spectacle of Indians eating with their fingers that she had to leave the theatre as soon as the second dinner episode commenced. But such squeamishness is not common. If details confuse, or offend, or go over the head, there is always the human element to fall back upon.

In *Apur Sansar*, Apu attends the wedding of a friend's sister. The bridegroom (this is an arranged marriage) arrives and is found to be touched in the head. With the bride's mother refusing to give away her daughter, the marriage seems on

Apu (Soumitra Chatterjee) weds Aparna (Sharmila Tagore) in *Apur Sansar*

the verge of being abandoned. If it doesn't take place at the appointed hour, the bride would be cursed and made unmarriageable for life. The crisis is averted at the last moment by Apu offering to step in as the groom. A Western viewer ignorant of orthodox Hindu customs must find the episode highly bizarre. But since Apu himself finds it so, and since his action is prompted by compassion, the viewer accepts it on moral grounds, though given no opportunity to weigh the pros and cons of a seemingly irrational practice.

Faced with a film from an alien culture, swamped by details which evoke no responses in him, a viewer will often find that the only aspect which offers a common ground is the moral one. Broad concepts of good and evil, right and wrong, do not vary

much from culture to culture. Human behaviour also falls within patterns which are largely familiar and predictable. Abnormal situations may affect such behaviour as, say, in Hitler's Germany; but as long as a film makes the context clear, a viewer is unlikely to lose his bearings. This can happen only when the development of the story itself turns on social and historical factors of which the viewer has no knowledge.

The Western critic who hopes to do full justice to *Devi* must be prepared to do a great deal of homework before he confronts the film. He must read up on the cult of the Mother Goddess; on the nineteenth-century renaissance in Bengal and how it affected the values of orthodox Hindu society; on the position of the Hindu bride in an upper-class family, and on the relationship between father and son in the same family. All the turns and

Dayamoyee (Sharmila Tagore) as the goddess in *Devi*

twists of the plot grow out of one or more of these factors. The Western critic who hasn't done his homework will pin his faith on the rational son to save him from the swirls and eddies of an alien value system; but even here the son's ultimate helplessness will convince him only if he is aware of the stranglehold of Hindu orthodoxy in nineteenth-century Bengal. *Devi* was widely condemned in India as an attack on Hindu religion when what it really attacked was fanaticism. This is one instance out of many of the obstacles faced by the serious film-maker in India.

Amal (Soumitra Chatterjee) and Charu (Madhabi Mukherjee) in the garden sequence in *Charulata*

In a film like *Charulata*, which has a nineteenth-century, liberal upper-class background, the relationship between the characters, the web of conflicting emotions, the development of the plot and its denouement, all fall into a pattern familiar to the Western

viewer. The setting is a Western-style mansion, the décor is Victorian, the dialogue strewn with references to Western literature and politics. But beneath this veneer of familiarity the film is chock-a-block with details to which he has no access. Snatches of song, literary allusions, domestic details, an entire scene where Charu and her beloved Amal talk in alliterations (thereby setting a hopeless task for the subtitler) – all give the film a density missed by the Western viewer in his preoccupation with plot, character, the moral and philosophical aspects of the story, and the apparent meaning of images.

To give an example, early on in the film, Charulata is shown picking out a volume from a bookshelf. As she walks away idly turning its pages, she is heard to sing softly. Only a Bengali will know that she has turned the name of the author – the most popular Bengali novelist of the period – into a musical motif. Later, her brother-in-law Amal makes a dramatic entrance during a storm reciting a well-known line from the same author. There is no way that subtitles can convey this fact of affinity between the two characters, so crucial to what happens later. *Charulata* has been much admired in the West; so have many of my other films. But this admiration has been based on aspects to which response has been possible; the other aspects being left out of the reckoning.

Even those films of mine which have been admired have often been described by Western critics as being slow. Indeed, they often are slow, and there are several reasons for this. My first two films, *Pather Panchali* and *Aparajito*, had to be slow because of their subject matter. I knew I was taking a risk. What I didn't know was how difficult it is to sustain a slow pace without seeming ponderous and boring. Provided the subject is interesting, a film can hold an audience in spite of slowness by means of (a) an extreme precision of cutting which ensures that

shots are not held even for a split second beyond their expressive limits, and (b) an expressive soundtrack that helps to mitigate the slowness. A scene with its soundtrack turned off seems slower than it actually is because it withholds information, and is therefore less meaningful. Both *Pather Panchali* and *Aparajito* were rushed in the editing stage because of deadlines, and both had inadequate soundtracks. Faltering pace and long stretches of virtual silence affected the latter film more seriously because it was more episodic and less rich in human material than the first.

As for my other films, most of them are primarily about human relationships. To make characters credible and their interplay interesting needs footage. A fast pace would subvert all attempts at psychological probing. But some of the slowness may result from the fact that when a word, a gesture, an allusion or an image carries a special meaning, and is not understood as doing so, it may seem like a redundancy. A series of such apparent redundancies may well add up to a feeling of slowness – of time being wasted on inessentials.

To a Western viewer, my films dealing with life in the city today are less likely to seem slow not only because urban life itself is faster, but also because the viewer feels far less trammelled by cultural differences. Not only the physical aspects – lifestyle, dress, architecture, surroundings – but the subjects themselves must seem nearer home. Joblessness, corruption, the rat race, problems of the working woman – these are global themes. Young men and women facing these problems in Calcutta behave in much the same way as their counterparts in any big city in the West.

Even the speech of the educated Bengali is often peppered with English words and phrases. Western critics often seem bothered by this, perhaps seeing in it an unfortunate legacy of

imperialism. This being largely true is itself a justification for their use in films. But often these phrases convey feelings and nuances for which Bengali has no equivalents, just as English has no precise equivalents for blasé and passé. Sometimes, as in *Kanchenjungha*, a film may actually be making a point about the degrees of westernisation undergone by a given set of characters. This would come out in the frequency with which English occurs in their speech. One who desists from its use would suggest a different background and upbringing from one who doesn't.

The use of 'sorry' and 'thank you', for which few Indian languages have words, must surely have started as an aping of English manners. It has now become a habit with westernized Indians. Those who do not use them use the old substitute of gestures: a smile and a nod to acknowledge a favour; a pained, apologetic look and a click of the tongue where hurt has been caused – both coming more from the heart than their somewhat mechanical English equivalents.

'Classical' and 'humanist' are epithets often used by Western critics to describe my films. They are generally used as compliments, and occasionally, one suspects, as euphemisms for old-fashioned, a further insinuation being that my films are not innovative.

If classical implies an orderly unfolding of events with a beginning, a middle and an end – *in that order*; a firm rein applied to emotion, and an avoidance of disorientation for its own sake, I will be only too happy with the label. Apart from the fact that such traits are a reflection of my temperament, they are also necessary to my need for communication.

All my films are made with my own Bengali audience in view. As long as it takes a minimum of three years for any film I make to reach the West (it took twenty-four years for *Jalsaghar* to reach Paris), the Bengali audience will remain my first audience. This

audience has grown more perceptive over the years. As a result, I have managed to do without the three main ingredients of popular Bengali cinema: songs, melodrama and wordiness. Bengalis, who love the theatre more than they love films, love words for their own sake. But there is a large audience now who will not only listen, but use their eyes and their minds as well. This is the audience that makes a serious film a viable proposition, provided it tells a story which has the power to hold. A director who discards the popular elements and stops telling a story in comprehensible terms digs his own grave.

But I do not think that the story per se is old-fashioned. A plot which is seen to be a plot, a contrivance, is old-fashioned; but if it seems to grow out of the characters, and if it acquires a fullness through details that place it firmly in time and in a milieu, and on top of that give it a texture that is seen as a uniquely cinematic quality, it is no longer old-fashioned, nor even aptly described as classical. What is important surely is the sensibility that marks the progression from A to Z, and the sensibility and moral attitude that inform the exploration of human motives, human behaviour – in short, humanism.

I should be happier with the description 'timeless'. Bach is timeless. So is Masaccio. So is Buster Keaton. So are Indian and Egyptian sculpture, the murals of Ajanta, Chinese painting, Japanese woodcuts, Etruscan vases, Benin bronzes, the horse of Lascaux and the bison of Altamira . . .

Of course it would be an anachronism today for a composer to write music like Bach or Mozart; but for all film-makers to use the idiom of Jean-Luc Godard or Jean-Marie Straub in a do-or-die bid to be contemporary would drive them all out of jobs and empty all cinemas. As long as films call for big budgets and the resources of a large industry, as long as film-makers feel responsible to the individual or the corporation that provides

them with the means to be creative, the need to reach a large audience will be there.

As for innovation, all artists owe a debt to innovators and profit by such innovation. Godard gave me the courage to dispense largely with fades and dissolves, Truffaut to use the freeze. But all innovation is not external. There is a subtle, almost imperceptible kind of innovation that can be felt in the very texture and sinews of a film. A film that doesn't wear its innovations on its sleeve. A film like *La Regle du Jeu*. Humanist? Classical? Avant-garde? Contemporary? I defy anyone to give it a label. This is the kind of innovation that appeals to me.

Although I have acknowledged my debt to Western classical music, it is difficult to pinpoint where such debt is to be felt in my films. Cinema has an obvious affinity with music in that both exist as fixed patterns in time. But film is concerned with subject matter, while music, at least in its instrumental form, is not. When I talk of Mozart as an influence, I am thinking more of his operas and his miraculous ability to have groups of characters maintain their individuality through elaborate ensembles.

The memory game in *Aranyer Din Ratri*

Leporello's stuttering fright, the Don's bravado in the face of doom and the Commendatore's relentless intoning of his challenge in the Statue scene in *Don Giovanni* is but one example out of many. I am greatly fascinated by the possibility of such ensembles in films. The memory game in *Aranyer Din Ratri* attempts this. Here the game itself is the ground bass over which the six characters play out their individual roles in word, look, and gesture.

There is another such scene in *Charulata* involving four 'voices'. Amal's unexpected duplicity has stung Charu to the quick, and she runs through a whole gamut of feelings – shock, disbelief, smouldering anger, heart-wrenching agony – assuming with supreme effort a normal façade when her unsuspecting husband butts in, spouting politics, while a self-centred Amal, flushed by his first literary success, rubs salt in Charu's wound by his unfeeling ebullience – the entire goings-on observed with pensive detachment by Manda, Charu's earthy, uncomplicated sister-in-law. This is the scene where the note of tragedy is struck for the first time, and it is this note which, like a pedal-point, holds the scene together.

I am fully aware now, thanks to my Western critics, of the Western traits in my films. They have so often been brought to my notice that I can actually name them: irony, understatement, humour, open endings, the use of leitmotifs, a fluid camera and so on. These elements are never used consciously. It is not as if I find myself saying: Ah, now for a bit of British understatement. They are used intuitively to best serve the needs of the subject matter in hand. I only try to tell a story in the best possible way, balancing the needs of art with the need to reach an audience. By no means a unique preoccupation for a film-maker, but perhaps involving more risks than usual in the context of India. The Western elements often perturb the Indian viewer in the same

way as the indigenous elements perturb the Western viewer. *Kanchenjungha* turned out to be so Western in feeling that it put off most Indian viewers. *Aranyer Din Ratri* provoked comments like: What does the film say? Where is the message? Why isn't the director more articulate? Actually the film says a lot, but not always in words, certainly not in those of rhetoric. But who bothers to read between the lines of a film?

What is attempted in these films and in most other films of mine is, of course, a synthesis. But it can be seen as such only by someone who has his feet in both cultures. Someone who will bring to bear on the films involvement and detachment in equal measure. Someone who will see both the wood and the trees.

That Indian films can set up a cultural barrier for Indians is a fact brought home only recently. A resurgence in Indian cinema has thrown up young and promising film-makers in regions new to film production. Faced with films from the provinces of Kerala, Karnataka, Andhra and Tamil Nadu, a Bengali finds himself in a position not so different from a Western viewer confronted with the same films. Underlying the broad cultural pattern that is India, a thousand disparities in behaviour, habits, rituals, dress, topography, language and so on make these films less immediately accessible to a Bengali than an average film from Europe or America. Even the sound of an unfamiliar language can be disconcerting. The Japanese grunt can still provoke a snicker in a bad Japanese film where one is not obliged to be on one's best behaviour as in a film, say, by Ozu. I don't envy the Western critics who are suddenly faced with this bewildering array of sub-cultural variations.

No wonder it has led to some serious aberrations of judgment. The chorus of praise showered on the south Indian mythological film *Seetha Kalyanam* (*Seetha's Wedding*) launched it on an invitation tour of the international film festival circuit where it won more praise. And yet, in fifty years of film-going, I have not

come across a more flagrant exhibition of unmitigated kitsch. As a cultural hybrid which takes an episode from one of the two great Hindu epics, swamps the interiors with Persian carpets, Mughal chandeliers and comic-strip wall paintings; floods the soundtrack with what is claimed to be classical Carnatic music, but turns out mostly to be high-decibel film songs a la Bombay; punctuates the story with camera tricks that were already clichés in the early days of the talkies; and wraps the whole thing up in the colours of a chocolate box, *Seetha Kalyanam* is a concoction par excellence. One could see it as being mildly enjoyable as camp, though that is not how the critics saw it. They took it seriously.

This indicates a collapse of sensibility which would send them all back to square one as expositors of Indian cinema to the West but for the fact that one knows too well the traps a film in an unfamiliar genre from an unfamiliar culture can set for a critic. Once, sitting on the jury in Moscow, I found a Soviet colleague, a distinguished film-maker, driven to paroxysms of laughter by a particularly mirthless comedy from the West. I asked him later what he found so funny. He was apologetic. 'You see,' he explained, 'we see so few comedies here that we really don't know what is funny and what is not.'

I suppose for a critic such frank admission of bafflement would be possible only at the expense of his claim to be one step ahead of the audience and the film-makers at all times. Such single-mindedness must take its toll, and one commiserates with him. But one also feels grateful to the critics for all that they have done to promote the cause of the new Indian cinema in the West. It is more important for the West now to see our films than to understand them. In any case, true understanding will take time. Slighted for so long, India will not yield up her secrets to the West so easily, for cows are still holy here, and God is still a phallus.

14

THE ART OF SILENCE

A MAN CALLED Edwin S. Porter discovered one fine morning that you could tell stories with moving pictures just as you could tell them with words, and he proceeded thereupon to make a motion picture called *The Great Train Robbery*. The year was 1903, and the place was America, and this was obviously a case of great things having a small beginning. For although a clever man, Porter could hardly have guessed that in making this fourteen-minute film, he was laying the foundation of the powerful art form of the twentieth century – the only art form, in fact, whose birth and evolution is part of recorded history.

Now, in 1903, the year of *The Great Train Robbery*, Picasso was modulating from his Blue to his Rose period. The great impressionists were all active and at the height of their powers, but Paul Gauguin was dying neglected in a remote South Seas island.

In the field of music, Igor Stravinsky was about to join forces

Inaugural address at the screening of a session of silent screen classics held in Calcutta under the aegis of the Calcutta Film Society; preserved in Ray Scrapbook, No. 8, dated, 12 March, year not mentioned

with Sergei Diaghilev to write some of the most original and striking of modern ballets. Elsewhere, the seeds of modern music had already been laid by Arnold Schoenberg and Béla Bartók, in the theatre – in the year of *The Great Train Robbery* – G.B. Shaw had just finished writing *Man and Superman*. Gordon Craig was about to publish his *Art of the Theatre*, and Konstantin Stanislavsky, in Russia, was engaged in meticulous and revolutionary productions of the latest plays of Anton Chekov.

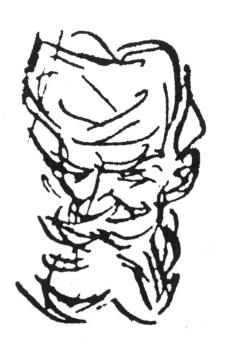

George Bernard Shaw
(sketch by Satyajit Ray)

One would have thought that in Europe, where so many intellectuals were engaged in such diverse creative pursuits, the potentialities of the new art form would be recognized quickly enough. But such was not to be passing interest in the new medium – or the new toy, as some preferred to call it, although one must mention the Frenchman Lumiere who did have some fun with the toy and produced what are now generally regarded as the first genuine primitive films.

Perhaps inevitably, cinema was obliged to discover its roots in a country which had no traditions of its own – in the United States of America. If it was Edwin Porter who discovered that you could tell stories with a camera, it was left to a far more talented American, David Griffith, to raise the film to the level of art.

As one who has come into the field at an advanced stage in the development of the medium, I can't help marvelling at the way pioneers made discovery after discovery about the unique properties of this brand of new art form. What an extraordinary thrill it must have been to realize that you could move your camera close to an actor and catch a movement of his eyes and convey a shade of feeling which no actor on the stage could ever hope to convey to his audience! Or that you could put your camera on a hill top and convey the movement of a whole army, and fill the theatre with the surge and excitement of real battle. Equally exciting must have been the discovery that you could actually join separate shots so that they made sense, just as a string of words forming a sentence made sense.

Then again, in films you arranged forms in a rectangular space, as you did in painting. This was the exciting discovery – if your objects moved, or your camera moved, or both moved at the same time, you found yourself thinking more of the art of choreography.

Then there was the affinity with music. It's a significant fact that most of the pioneers of the cinema are known to have been seriously interested in music. Griffith used to speak of the inspiration he derived from the music of Ludwig Beethoven, and one can actually spot the symphonic structure underlying films like *The Birth of a Nation* and *Intolerance*.

This isn't surprising. Film is the only art apart from music which exists in time. We respond to music because our nerves are made to respond to certain qualities inherent in music – qualities of timbre, of rhythm, of melody. A good film, too, inevitably reveals these qualities, although they can't be reduced to mathematical terms. They remain indefinable and elusive but they can be felt. And it is these qualities, and not the turns and twists of the plot, that compel us to see a great film again and again.

It's surprising that there should still be people who doubt the claims of the cinema to be regarded as art. They say films don't have the purity of painting, or the abstract qualities of music, or the analytical scope of the novel, or the intensity of the theatre. To me, this tendency to run down an art form because it doesn't have certain properties of some other art form, or to look for traits which by its very nature it can't possess, seems childish and pointless. Perhaps the trouble started with the coming of sound, when cinema began to derive more and more from the theatre and the written word. The trash that has been perpetrated in the era of sound in the name of art and box-office and God knows what, is beyond measure. It's ironical that this deviation from the path of art should have taken place first in the land which indicated the true status of cinema. At any rate, it's taken all of thirty years for cinema to find its bearings again, and for true artists to begin emerging from the rubble, and for a new set of aesthetics to be formulated.

At long last we know cinema for what it is – a language, an enormously potent and flexible language, a language that can be used in just as many different ways as you can use the language of words.

In the silent era, this was a language of images. Ever since the talkies ruthlessly replaced the silent film, it has been a language of image and sound. I believe the silent film to have been an entirely different art form from the sound film, and there was no aesthetic justification for one to have replaced the other. Chaplin didn't regret the coming of sound as much as its inevitable consequence: the strangulation of an already speechless art. To some it appeared as if sound was liberating cinema from some constricting limitation, as if the film without tongue was an unfortunate cripple, and the man with the microphone had come to perform a miracle of surgery.

Of course, it was nothing of the kind. What sound did was to bring cinema closer to reality, to life as it is perceived through our senses of sight and hearing. But in doing so, it inadvertently unleashed all manner of forces which tended to pull cinema away from its goal of art.

Films were now more life-like, everybody said. Here were men and women who walked and talked like you and I, and didn't do odd things with their limbs and eyeballs. If the silent cinema was art, who cares? This was life or as near life as you could hope to get without actually getting involved in it. You only had to pay your nickel, lean back in your plush seat, and glance up at the charmed rectangle. This was cinema – this was what we'd all been waiting for.

No wonder silent films made a silent exit!

All this is not meant to belittle the sound film. I could hardly do that, being so happily involved in it myself. The point I'm trying to make is that the sound film is not an improvement on the silent film, but an independent art form with its own special appeal and its own special aesthetics. Ideally, the two should have coexisted. The fact that they couldn't do so only goes to prove the cruel illogicality of commercial pressures which decide the fate of films and film-makers.

Booklet cover for *Pather Panchali* designed by Satyajit Ray

Goopy (Tapen Chatterjee) and Bagha (Rabi Ghosh) in *Goopy Gyne Bagha Byne*: lobby card designed by Ray

Goopy (Tapen Chatterjee), Bagha (Rabi Ghosh) and the king of Shundi (Santosh Dutta) in *Goopy Gyne Bagha Byne*: lobby card designed by Ray

Arati (Madhabi
Mukherjee) and
Vicky Redwood
(Edith) in
Mahanagar: lobby
card designed by Ray

Amjad Khan as Wajid Ali Shah
in *Shatranj Ke Khilari*: lobby card
designed by Ray

Poster for *Nayak* designed
by Ray

A sketch by Ray of Outram's study for *Shatranj Ke Khilari*

An illustration by Ray for a children's edition of the novel,
Pather Panchali

Ray, Soumitra
Chatterjee and
Pandit Ravi
Shankar during
music recording
for *Apur Sansar*
(courtesy: B.D.
Garga)

Satyajit Ray
directing
Victor Banerjee
in *Ghare Baire*
(courtesy: B.D.
Garga)

Sharmila
Tagore, Ray and
cameraman
Subrata Mitra
on the sets of
Apur Sansar
(courtesy: B.D.
Garga)

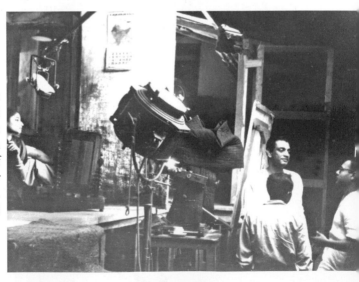

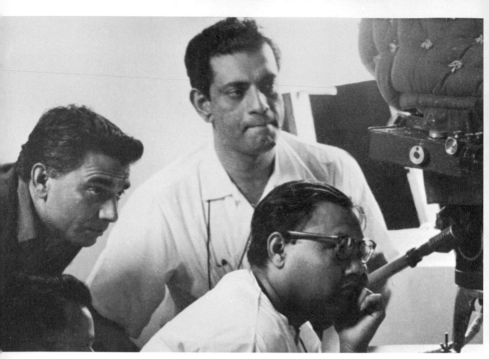

Art director Bansi Chandragupta, Ray and cameraman Subrata Mitra
on the sets of *Apur Sansar* (courtesy: B.D. Garga)

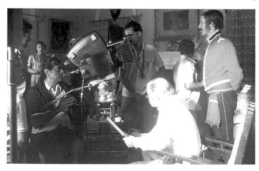

Ray on the sets of
Shatranj Ke Khilari
with Richard
Attenborough
(General Outram),
Tom Alter (Captain
Weston) and Victor
Banerjee (Ali)

Ray directs the
two chess players,
Mir (Saeed Jaffrey)
and Mirza (Sanjeev
Kumar), in
Shatranj Ke Khilari

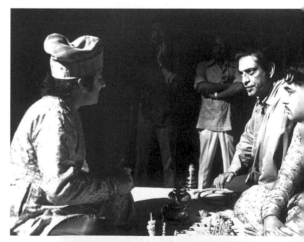

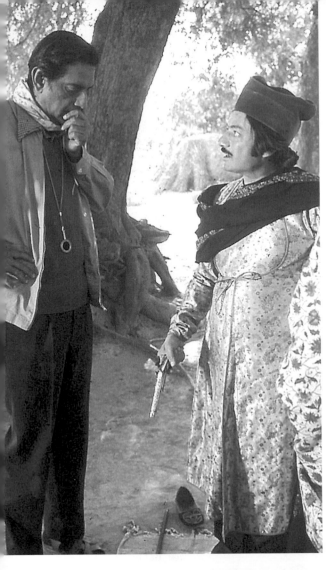

Ray with
Saeed Jaffrey
during the
outdoor shoot
for *Shatranj
Ke Khilari* in
a Lucknow
suburb

Ray with Birju
Maharaj and
a member
of his dance
troupe before
the shooting
of the dance
sequence in
*Shatranj Ke
Khilari*

John Ford, a sketch by Ray

Akira Kurosawa,
a sketch by Ray

Rabindranath Tagore,
a sketch by Ray

Uttam Kumar in Rome, photograph by Ray

Apu (Soumitra Chatterjee) and Aparna (Sharmila Tagore) in *Apur Sansar*

Gulabi (Waheeda Rehman) and Narsingh (Soumitra Chatterjee) in
Abhijan (courtesy: B.D. Garga)

Birinchi Baba
(Charuprakash Ghosh)
and his assistant
(Rabi Ghosh) in the
Mahapurush sequence
of *Kapurush-O-
Mahapurush* (courtesy:
B.D. Garga)

Harinath (Samit Bhaja), Sekhar
(Rabi Ghosh), Sanjay (Subhendu Chatterjee),
Asim (Soumitra Chatterjee) and Duli (Simi
Garewal) at the liquor shop in *Aranyer Din Ratri*

Sanjay
(Subhendu
Chatterjee),
Asim (Soumitra
Chatterjee),
Harinath (Samit
Bhaja) and
Sekhar (Rabi
Ghosh) in
Aranyer Din Ratri

Aparna
(Sharmila
Tagore) and
Asim (Soumitra
Chatterjee) in
*Aranyer Din
Ratri*

Bhupati (Sailen
Mukherjee) and
Amal (Soumitra
Chatterjee) in
Charulata

Charu (Madhabi Mukherjee) and Bhupati (Sailen Mukherjee) in *Charulata*

Umaprosad (Soumitra Chatterjee) and Kalikinkar (Chhabi Biswas) in *Devi*

The king of Halla (Santosh Dutta), Bagha (Rabi Ghosh) and Goopy (Tapen Chatterjee) in *Goopy Gyne Bagha Byne*

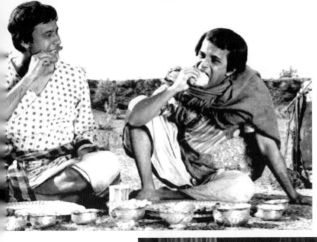

Goopy (Tapen Chatterjee) and Bagha (Rabi Ghosh) in *Goopy Gyne Bagha Byne*

Somnath (Pradip Mukherjee), Somnath's father (Satya Banerjee), Kamala (Lily Chakravarty), and Bhombol (Deepankar De) in *Jana Aranya*

Labanya (Karuna Banerjee, sitting), Haridhan Mukherjee, Ashok (Arun Mukherjee) and Indranath Roy (Chhabi Biswas, back to camera) in *Kanchenjungha*

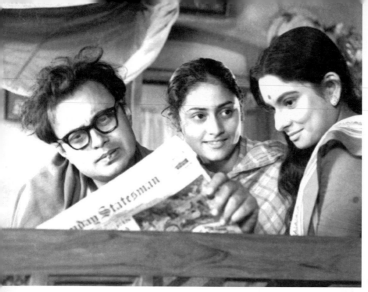

Subrata (Anil
Chatterjee),
Bani (Jaya
Bhaduri) and
Arati (Madhabi
Mukherjee) in
Mahanagar

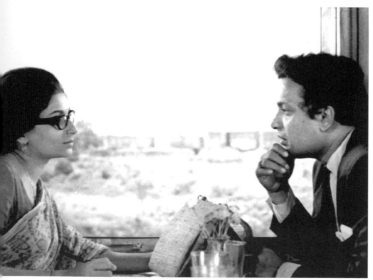

Aditi
(Sharmila
Tagore) and
Arindam
(Uttam
Kumar) in
Nayak

Durga (Uma
Das Gupta)
in *Pather
Panchali*

Siddhartha (Dhritiman Chaterji) with Keya (Joysree Roy) in *Pratidwandi*

Shyamalendu (Barun Chanda) and Deepankar De in *Seemabaddha*

Captain Weston (Tom Alter), General Outram (Richard Attenborough) and Wajid Ali Shah (Amjad Khan) in the Nawab's Durbar Hall in *Shatranj Ke Khilari*

Labanya (Karuna Banerjee)
and Jagadish (Pahari Sanyal) in
Kanchenjungha

Sudarsana
(Sharmila Tagore)
and Shyamalendu
(Barun Chanda)
at the races in
Seemabaddha

Subrata (Anil
Chatterjee) and
Arati (Madhabi
Mukherjee) in
Mahanagar

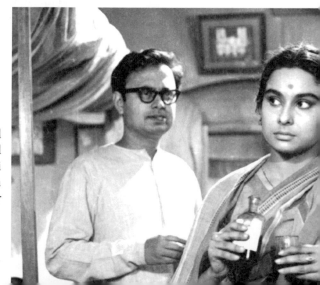

Poster for *Apur Sansar* designed by Ray

Poster for *Aranyer Din Ratri* designed by Ray

Poster for *Charulata* designed by Ray

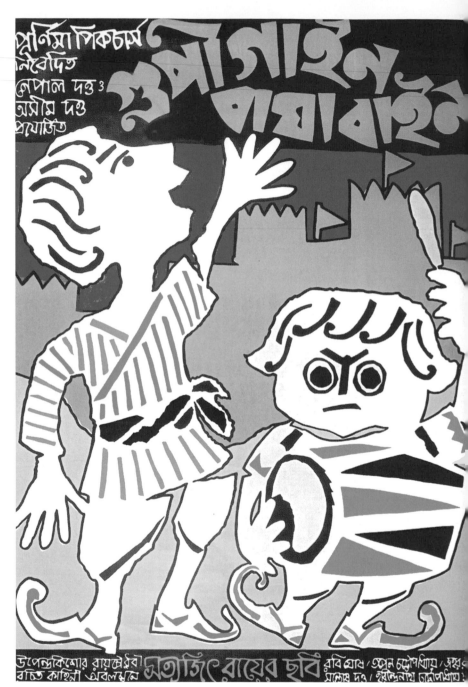

Poster for *Goopy Gyne Bagha Byne* designed by Ray

অরোরার
নিবেদন

তারাশঙ্কর
বন্দ্যোপাধ্যায়ের

জলসা ঘর

চিত্রনাট্য ও পরিচালনা
সত্যজিৎ রায়

শ্রেষ্ঠাংশে
ছবি বিশ্বাস

সংগীত
বিলায়েৎ খাঁ

সুরারোপে
সালামৎ খাঁ
আখতারি বাঈ
(ফৈজাবাদী)
বিসমিল্লা খাঁ
রোশন কুমারী
ওয়াহেদ খাঁ

Poster for *Jalsaghar* designed by Ray

Magazine advertisement for *Nayak* designed by Ray

Poster for *Seemabaddha* designed by Ray

Ray during the shooting of *Teen Kanya*

Part Two

PEN PORTRAITS

15

A WORD ABOUT GODARD

'I DON'T LIKE Godard' is a statement one frequently hears at Film festivals.

Now, I don't like Godard too. But then, 'like' is a word I seldom use to describe my feeling about truly modern artists. Do we really like Pablo Picasso, or Claude-Michel Schönberg, or Eugène Ionesco, or Alain Robbe-Grillet? We are variously provoked and stimulated by them, and our appreciation of them is wholly on an intellectual level. Liking suggests an easy involvement of the senses, a spontaneous 'taking to', which I doubt if the modern artist even claims from his public.

Godard has been both dismissed summarily, and praised to the skies, and the same films have provoked opposite reactions. This is inevitable when a director consistently demolishes sacred conventions, while at the same time packing his films with obviously striking things.

Godard's main unconventionality lies in completely doing away with development in terms of plot. Some make this claim

Link, 15 August 1966

for Antonioni too. But this is false. Beneath an exterior of apparent arbitrariness, Antonioni's films conceal an almost classical formal pattern. With Godard there is no such concealment.

Sometimes there is a theme. *Une Femme Mariée* may be said to be about a woman vacillating between her husband and her lover, and when you've said that, you've said everything – or nothing. The theme only serves as a springboard for a series of dissertations, some related to it, and some as wide off the mark as one can imagine.

Up till now, a director's hallmark was supposed to reside in his personal approach to his theme. One looked for the special signature of an artist. If Godard has a hallmark, it is in repeated references to other directors, other films (both good and bad), other forms of art, and to a myriad phenomena of contemporary life. These references do not congeal into a single significant attitude, but merely reflect the alertness of Godard's mind, and the range and variety of his interests.

The upshot of all this is that a Godard film assumes for me the aspect of a collage, and I for one am convinced that that is how his works ought to be judged, and that is where lies their aesthetic validity.

We know that in painting a collage is a form of abstraction in which seemingly unrelated elements are brought together

Pablo Picasso
(sketch by Satyajit Ray)

to create a pattern of contrasts. Some of these elements – such as a guitar or a wine bottle in a collage by Braque or Picasso – have 'meaning'. But since the guitar and the wine bottle are taken out of their context and placed in juxtaposition with elements wholly unrelated to the idea of music or drinking, they assume a quality of abstraction. What symbolic value still clings to them adds a subtle overtone to the collage – a touch of humanism in a mélange of tones and textures.

Likewise, Godard has scenes in his films which begin to suggest a human involvement. But they are inevitably cut short or developed with deliberate illogicality, as otherwise they would be 'conventional' and, therefore, out of key with the rest. In more than one Godard film, key characters have been killed off by gunmen at the end, and there have been no logical reason for such obliteration.

Now, to a mind attuned to the conventional unfolding of plot and character, such things may well seem upsetting. But one can never blame Godard for thwarting expectations, for he is careful to establish his credo from the very opening shots. In *Une Femme Est Une Femme*, there is a prologue in which some of the main sources of the film's style are actually named in screen-filling letters. *Vivre Sa Vie* states clearly in the credits that it is 'A Study in Twelve Scenes' and *Masculin Feminin* calls itself a film in fourteen fragments.

The trouble, really, is not with Godard, but with his critics – or, at least, a good many of them – who are constantly trying to fit a square peg into a round whole. With any other art, I would have said with confidence that Godard would win in the end. But in the ruthless and unserious world of commercial cinema that he has to operate, I have my doubts.

16

THE NEW ANTONIONI

THERE IS A key scene in Michelangelo Antonioni's new film, *Blow-Up*, where the photographer-hero Thomas (played by David Hemmings) contemplates some enlargements of photographs he had taken in a London park while looking for 'something lyrical' to go in an album of his work. A stroke of luck had provided a distant view of an embracing couple – youngish woman (Vanessa Redgrave) and a middle-aged man – to add human interest to the wind-blown trees and the wide expanse of grass. The girl had actually caught him snapping and kicked up quite a row, demanding that he stop shooting and give up the roll of film. Thomas, of course, had been well within his rights to refuse: 'This is a free country' . . . etc.

Studying the enlargements now, Thomas is struck by the way the girl's head is turned anxiously away from her lover in one of them. Since there is no stream-of-consciousness narration on the soundtrack, we never know why he discards the possibility of the girl reacting to a sound, which might have produced the

Xth Muse, Film Bulletin of Chalachitram, 1967

Michelangelo Antonioni at the Taj Mahal (photo by Satyajit Ray)

same turn of the head. At any rate, the next thing Thomas does is to run his finger along the line of her look to see if it leads to something. It leads to a hedge. Is there something in the hedge to reveal what she's looking at? No; but Thomas decides to pursue the investigation by blowing up a portion of the hedge – an area approximately 5mm in width of the original 35mm negative.

This second blow-up goes up on the board now for scrutiny. Eureka? Not quite, but there's a tiny blob of white which to the clairvoyant Thomas looks promising, and which a simple mental calculation tells us ought to be something with the dimensions of a bee. Thomas has the blob masked off, and proceeds to do another twelve-by-fifteen, using about a twentieth part of the original frame.

The third enlargement is now pinned up, and – hey presto! – there's a five-fingered human hand with a gun nuzzling out of the hedge with the obvious intent to kill.

At this climactic point of the scene which has been widely acclaimed as a masterpiece of cutting, I felt like walking out on Antonioni. The whole raison d'être of *Blow-Up* is contained in this crucial revelation through a photographic enlargement. In reality, the third blow-up would have been just a conglomeration of blobs – a sort of pointillist photographic abstraction – with no recognizable elements whatsoever to serve as tell-tale clues. By his flagrant violation of this fundamental photographic truth, Antonioni both reveals and destroys the frail foundation of his story. I can't recall a single instance of a major director having done this sort of thing before.

But Antonioni must have his gun, because Thomas must pursue the mystery, not because anybody wants it cleared up – *Blow-Up* is not cast in the mould of a whodunit – but because, if he didn't, there would be no pot party, no symbolic tennis match, no *Vanessa de nuda*, and finally, no box-office for this obviously

expensive MGM-backed English-language debut of cinema's most sophisticated analyst of contemporary malaise.

One is really hard put to find anything in *Blow-Up* to raise it to the level of a serious social analysis – which most of Antonioni's past films have been. Even judged as pure cinema, there isn't much to commend beyond a sensitive soundtrack and some effective mise-en-scene in the photographer's studio. The much-touted 'pace' of the film is a myth. I have seldom seen a film which has so little 'inner' movement, in the sense of characters growing, relationships developing, or even just a story unfolding. Antonioni is aware of this, and tries to make up for it by a good deal of gratuitous physical movement – mainly Thomas whizzing up and down London in his Rolls and, in one scene, cavorting with a couple of moronic, *deshabille* models amid rolls and rolls of purple backdrop paper.

Thomas is the only person in the film who even begins to exist as a character. He is shown as smug, ruthless, amoral and successful. In so far as he is observed at work – whether jousting with his models in his studio, or crouching for the 'decisive moment' out in the open – he is both interesting to watch and believable (which also serves as a comment on Hemmings's work). But when his smugness begins to crack and the peeling off begins, we cease to become involved, because what triggers off the process – the discovery of the murder – never assumes the dimensions of a truly affecting experience.

On discovering the dead body in the park following the revelation of the gun in the enlargement, what Thomas does is to go and look for his friend in – of all places – a pot party. How he does so with any expectation of wise counsel or concerted action is a mystery. And then he goes back from the party to the park to find the corpse gone, and from the park back to the studio to find all the crucial photographic evidence gone. Unsolved mystery piled upon unsolved mystery. But who cares?

One could, perhaps, accept *Blow-Up* as a slick film about shallow people, but what, then, is the symbolic Felliniesque tennis match doing at the end? There is nothing in the rest of the film to justify a rounding off with a deep metaphysical comment on illusion and reality. But that is exactly what Antonioni is trying to do with all those painted-up mimes swiping away at non-existent tennis balls. Thomas is made to watch this game of make-believe, and be affected by it to the extent that when the ball is lobbed out of the court, he picks it up and throws it back to the players.

Perhaps the artistic significance of *Blow-Up* is like Antonioni's tennis ball, which a vast number of critics and filmgoers seem to have picked up and handed back to the Maestro. I, for one, am still looking.

**Michelangelo Antonioni, Akira Kurosawa and Satyajit Ray
at the Taj Mahal**

17

THE NAYAK

I WAS NOT a film-maker yet when I first saw Uttam on the screen. I had heard of the emergence of the new hero and was curious to see what he was like. The heroes that one saw on the Bengali screen those days – Durgadas Banerjee, Pramathes Barua, K.L. Saigal, Dhiraj Bhattacharya – were hardly in the same league with the Hollywood heroes one admired.

I saw three of Uttam's films in a row, all made by one of our ablest directors, Nirmal Dey.

First impressions were certainly good. Uttam had good looks, a certain presence, an ease of manner, and no trace of the theatre in his performance. He, obviously, had a future.

The opportunity to work with him came much later. By the time, Uttam Kumar had already become something of a legend. Every other Bengali film had him in the lead, usually paired with Suchitra Sen. This was a romantic team which for durability and width of acceptance had few equals in world cinema. Uttam was certainly a star in the true Hollywood sense of the term. The

Sunday, 3 August 1980; Uttam Kumar worked with the author in two films, *Nayak* (*The Hero*) and *Chiriakhana* (*The Zoo*)

question was: was he also an actor?

This is a moot question. There is at least one known instance in Hollywood of an actor with no acting abilities whatever who was propelled into stardom on the strength of the fan mail he received after his first film opened. This was Gregory Peck, who remains to this day, I am told, an actor 'who needs handling'. But Uttam, even in the most inconsequential of parts, exuded confidence which Peck never did.

Uttam Kumar in Rome
(photo by Satyajit Ray)

I was anxious to work with Uttam and wrote a part with him in mind. It was a part I thought he would find easy to identify with, being that of an ordinary, middle-class youth who gets a break in films and quickly rises to the top. In fact, a rags-to-riches story with some resemblance to Uttam's own life.

Uttam liked the part and accepted to do it, although he could see that it meant shedding – at least for the time being – of his glamour-boy mannerisms. He also agreed to use no make-up, although a recent attack of chickenpox had left its mark on his face.

I must say working with Uttam turned out to be one of the most pleasant experiences of my film-making career. I found out early on that he belonged to the breed of instinctive actors. I have worked with the other kind too, the cerebral one, the one that likes to take a part to pieces and probe into background, motivations, etc., in order to 'get beneath the skin of the character'.

Arindam (Uttam Kumar) in *Nayak*

But the fact is, there is no guarantee that a cerebral actor will make a more substantial contribution than an instinctive one. I hardly recall any discussion with Uttam on a serious, analytical level on the character he was playing. And yet he constantly surprised and delighted me with unexpected little details of action and behaviour which came from him and not from me, which were always in character and enhanced the scene. They were so spontaneous that it seemed he produced these out of his sleeve. If there was any cogitation involved, he never spoke about it.

I understand Uttam worked in something like 250 films. I have no doubt that well over 200 of them will pass into oblivion, if they have not already done so. This is inevitable in a situation where able performers outnumber able writers and directors.

**Arindam (Uttam Kumar) with Jyoti (Nirmal Ghosh)
in *Nayak***

**Sankar (Somen Bose) with Arindam (Uttam Kumar)
in *Nayak***

Even the best of actors loses his edge and languishes without a reasonably steady supply of worthy material to keep him on his mettle. It is even worse with 'stars', whom circumstances have brought to a pitch where they must stick to their 'image' or topple. And this usually means doing the same thing over and over again.

An artiste, however, must always be judged by his best work. On that basis and within the gamut in which his talent was best revealed, Uttam's work shows rare virtues of grace, spontaneity and confidence. Such a combination is not easy to come by, and it is hard to see anyone taking his place in the cinema of West Bengal in the near future.

18

'NEVER USE ANIMALS'

I MET INGMAR Bergman for the first time in the flickering half light of the auditorium of the Swedish Film Institute where he was watching Jack Smith's *Flaming Creatures*. I was introduced, sat down beside him and watched it too. We laughed a great deal. Later, we had tea and toast in the canteen of the Institute and talked about films. He described some of his shooting experiences, particularly one with a cat which gave him a lot of trouble. 'Never use animals,' was his advice.

On my first visit to Stockholm, I was particularly keen to meet Bergman as I had been a great admirer of his work ever since I saw *The Seventh Seal* way back in the mid-fifties. Bergman of today is not the Bergman of thirty years ago. He has pared down his style to a chamber music austerity. But he is still capable of handling big subjects, as witness *Fanny and Alexander*. At the opposite and more characteristic pole lies *Scenes from a Marriage*, a relentless study of two people – husband and wife – compelling and exhaustive.

Chaplin Film Magazine, 1988

Ingmar Bergman (photo by Satyajit Ray)

Bergman's craftsmanship has always been impeccable, and I envy the wonderful group of performers he works with. He has been threatening to give up films for a long time in order to concentrate on his first love: the theatre. Unfortunately, it is not possible for us in India to see his stage productions. On his seventieth birthday, may I wish him a long life and express the fervent hope that he will not give up cinema.

Charlie Chaplin
(sketch by Satyajit Ray)

19

THE IMMORTAL TRAMP

IF THERE IS any name which can be said to symbolize cinema –
it is Charlie Chaplin.

Chaplin revealed his genius in the early decades of the
twentieth century by creating the character of the Tramp – an
archetype which endeared him to the whole world. As a master
of mime, Chaplin was as adept at making people laugh as
making them cry. When the talkies came, Chaplin at first resisted
them, and made *Modern Times* as a silent film seven years after
the coming of sound. Later, he went on to make a number of
sound films where he abandoned the Tramp character, and
revealed new facets of his personality and a new social awareness.
I am sure Chaplin's name will survive even if cinema ceases to
exist as a medium of artistic expression.

Chaplin is truly immortal.

Charlie Chaplin: A Centenary Tribute, A brochure published by Nandan, 16
April 1989

Part Three

CELEBRATING CINEMA

20

ARRIVAL IN MOSCOW

WE CAUGHT THE Ilyushin for Moscow at Copenhagen. It was 4.30 in the afternoon, and the flight was to take two hours.

We had first-class tickets, but we couldn't spot a single vacant seat. This was odd. We stood perplexed and ill-at-ease for a minute or so when the hostess camp up, took one look at the tickets, and directed us to the tourist section. She was followed by a stout man in uniform who said in a tone of apology that there was probably some mistake: probably SAS had sold more tickets than there were seats.

We settled in our seats. Luckily there was a little more leg room than usual. Your knees didn't bump against the back of the seat in front, but against the knees of the man who sat facing you across a table, rather as in the cubicle of a restaurant.

It was hot and humid. I looked up to see if I could turn on the air vent, but there wasn't one. And no personal reading light either. Russian planes just didn't have them.

Half an hour after the take-off I asked the air hostess if it was

Mainstream, 7 September 1963

all right to smoke and unfasten our belts, as the sign hadn't been switched off yet. She said yes, it was: the sign had been kept on by mistake.

Chock-a-block

Two days ago I had sent a cable to the festival authorities giving our flight number and the date of arrival. But there was nobody to receive us at the airport. We followed the other passengers into what seemed like a waiting room. We stood around for about fifteen minutes without drawing any attention from anybody whatsoever. Then we settled in a couple of tubular chairs (1940 vintage) and hoped for deliverance. Right behind us was an enormous TV set. From the ceiling hung a twelve-branched chandelier.

The room was chock-a-block with delegates, interpreters and press photographers. I could spot the American actress, Susan Strasberg, who had shot into fame as Anne Frank on Broadway, and was not a film star. There was also a French couple, and a group of what seemed like Indonesian or Vietnamese delegates, including a charming young girl – an actress, surely – whose soft face was lit up again and again with light from flashbulbs.

It was past seven when we were approached by a young girl who asked us in English if we were from India. We said we were. 'Oh,' she said, 'so you've come. Yeena is waiting for you at the hotel.'

'Yeena?'

'Your interpreter.'

'But why isn't she here?'

'You see, she didn't want to come all the way and then find that you hadn't come.'

'But why shouldn't we come? We said we were coming. We had sent a cable.'

'Anyway, I'm supposed to interpret for the Tanganyikan delegates, and they haven't come yet, so I'll see about your luggage and your transport.'

She went off and came back after half an hour.

'May I have a cigarette?' she said.

I gave her one and she went off again.

It was nearly nine when we found ourselves in a car bound for the city. Our luggage would follow us in the bus, we were told. I sat next to the driver, a rotund man with bushy eyebrows and a shock of dark, wavy hair. The Tanganyikan delegation not having arrived, Eva, the interpreter, came with us in our car.

Taxi driver

We drove for a little while past darkening woods etched with tall, white-barked birch trees. Then the woods ended and the vista opened out. Eva introduced the driver to us. 'This is comrade so-and-so. He is a film worker.'

'Is he?' I was intrigued.

'Yes. He worked with Comrade Bondarchuk on his last film.'

'Is that so?'

'Yes,' said the man, turning to me. 'I was the cameraman of *The Fate of a Man*.'

I tried to envisage an equivalent situation in India where top-ranking Indian film workers would be transporting foreign film delegates from airports to hotels, and found it difficult.

It took us an hour to reach our destination. On alighting from the taxi, we thanked our eminent charioteer, and he, in his turn, nearly dislocated my knuckles in the warmest handshake in my experience.

There was a patient crowd outside the hotel entrance, waiting, we were told, to catch a glimpse of Danny Kaye, who had arrived the day before.

Babel of tongues

The Moskva is large – twelve storeys – and houses all the film delegates. Like most Moscow architecture, it lacks style and elegance to an unbelievable degree. The lobby occupies the entire ground floor. It was now filled with a milling crowd of delegates, journalists, festival personnel and the like, and the babel of tongues was truly deafening. I spotted a tobacconist's stall in a corner. There was also a magazine stall, and a couple of other stalls sold souvenirs. They were all shut now.

Eva had left us, and now emerged through the crowd with another woman, thirtyish, plump, and with an engaging smile of greeting which shifted quickly between my wife and myself.

'This is Yeena,' said Eva. 'From now on she'll look after you.'

Yeena shook hands with us. 'Welcome to Moscow . . . I thought I'd wait in the hotel for you. Did you have a nice trip?'

Yeena spoke sweetly, and with a 100 per cent American accent. 'Come and sit in the office while I see about your room. You haven't had supper, I suppose.'

I told her that the last meal we had was on the London–Copenhagen flight, at one o'clock.

'I see. Then I must see about your meal tickets too. Please let me have your passports.'

Yeena took our passports and disappeared down the lobby towards some unknown destination. I had begun to worry a little about the luggage.

We elbowed our way into the office and managed to find two more tubular chairs. More crowd, more babel of tongues.

Yeena came back half an hour later. 'I was waiting in the reception for your luggage to arrive'

'Has it come?'

'Not yet. But maybe in the meantime we should go and see the secretary. He's on the seventh floor. He'll tell you all about your programme.'

Hemingway 'wunnerful'

Walking to the lift I asked Yeena if she had acted as an interpreter in the two previous festivals.

'Oh no. This is the first time. I thought it would be a good opportunity to try out my English. I've been studying for four years. Next year I hope to take up Portuguese.'

'Have you read any English novels?'

'Oh yes. Hemingway . . . and others.'

'Do you like Hemingway?'

'Oh, he's wunnerful.'

We found the secretary talking to some French delegates. He was a lean man with grey hair and sad eyes, and he spoke what sounded like excellent French.

Our turn came in ten minutes.

'Oh, I'm so glad you could come, Mr Ray. Mr Yutkevitch was very keen that you should come.'

His English was at least as good as his French. I asked him where Mr Yutkevitch was.

'He's been ill. He's convalescing in Leningrad. I'm afraid he won't be able to come to the festival.'

Sergei Yutkevitch had seen my Trilogy at the Cinematheque in Paris. In fact, he was the only Russian director who knew my films well. I felt damped.

'Here's the programme,' said the secretary, handing me a yellow brochure with an atrociously designed cover. 'The formal opening's tomorrow evening, with the Baluyev film. From the day after, you start working in right earnest.' The secretary smiled in benign sympathy. 'I know it's hard work.'

'Yes,' I agreed, glancing casually through the brochure. 'But it's a little better here with only two films a day. In Berlin we had to see three and that's no work, that's torture.'

The secretary raised his eyebrows a little. 'It's three here, too,' he said.

Pulverizing morale

I was aghast. If anything was ever designed to pulverize my morale, this was it. When I had received the invitation from Moscow to sit on the festival jury, I had written back to say that I would accept only on condition that it didn't involve seeing more than two films a day; and the festival had replied that two would indeed be the number of films we would be required to see.

I plunged my hand into my overnight bag and produced the letter which said this, and showed it to the secretary.

He read it and shook his head. 'There's been a mistake somewhere.'

'A pretty big one, you must admit.'

'I'm sorry.'

The meal tickets, said the secretary, would be valid from the following morning.

'But,' Yeena showed a sudden burst of sympathy, 'Mr and Mrs Ray haven't eaten anything since one o'clock. And they haven't any money. And the restaurant is closed.'

'That's very unfortunate. You see it's such a turmoil today, with so many guests arriving. Everything will be all right from tomorrow. Meanwhile' – turning to Yeena – 'why don't you show Mr and Mrs Ray to their room. It's a very nice room. It's where' – turning to me – 'Mr Mehboob Khan stayed last time.'

We left the secretary. On my way down I asked Yeena if she knew who else was on the jury. I knew already that the actual process of viewing the films was bound to prove dismal and exhausting, but if the composition of the jury was interesting, one could at least look forward to the discussions. But Yeena wasn't particularly well informed.

'There's Chukhrai, who is the best of our younger directors.'

'I know. And who else?'

'Well, there's someone from America, and someone from France, and someone for Italy and . . .'

'I see.'

'I'll show you to your room. You can have a wash. I'll come back and wait for your luggage downstairs, and send it up as soon as it arrives.'

Only star

Our room was 964, on the ninth floor. We opened the door and staggered in. I must say the look of it did cheer us up a bit. The sitting room was large and airy. There was a nice carpet on the floor and the sofas looked inviting. In one corner was a television set, and on the left, against the wall as we came in, was a piano. I lifted the lid. Ukraina. I ran my fingers over the keys, and the room was filled with jangling quartertones. I walked over to the desk, the telephone was ringing. It was Yeena. She was calling from the reception.

'Did you say two large light-grey suitcases?' she asked.

'Da, da.'

'Well, they're here, and they're being sent up.'

'Very good.'

'And a bar of chocolate . . . See you tomorrow. So long!'

A faint whirr of traffic came through the window. I walked over and pulled aside the curtain. The magnificent Red Square came into view.

There was a haze in the sky, and the only star that showed was the red one over the Kremlin. A little to its left, round and full and friendly, and as big as I ever remember seeing it, was the moon.

21

FILM FESTIVALS

MY FIRST FILM, *Pather Panchali*, found its way to the Cannes Film Festival through the efforts of some sympathetic friends. I had no means of going, so I stayed back and held my breath. As I learnt later, the official screening of the film took place around midnight. The jury had already, on the same day, sat through four long features and decided to skip the Indian entry. Among the handful who attended were some critics, apparently with insatiable appetites, who sat through the film and liked it enough to insist on a second screening for the jurors. This was arranged, and the film went on to win a special prize as the 'best human document'.

The next year, my second film, *Aparajito*, went to the Venice festival and won The Golden Lion. This time I was present and experienced the rising tension that marks the occasion for a competing director.

Between Venice in 1957 and now, I have participated in more than twenty film festivals, either as juror, or with a film in

Span, August 1974

competition. The two experiences have nothing in common. As a juror, one submits to the onslaught of films – eight to ten hours of screening a day on an average – as well as to the endless round of parties. Some festivals have more of these than others. At any rate, there is little time left for the jury for anything except these two obligatory occupations. At parties, the jurors talk of everything except films lest the conversation should veer inadvertently towards 'what one has seen so far'. All festivals insist on secrecy, with the jurors told unequivocally to wear masks of inscrutability. This is because the awards are meant to come as surprise to the public.

They never do. For instance, in Venice one evening, two days before the prizes were announced, I was sitting in a pavement café when a stout, middle-aged man, presumably a journalist, sidled up to me, bent down to whisper dramatically into my ears 'I can hear the lion's roar!' and melted away into the gathering darkness.

Although all European festivals preview the films that are entered and are free to drop anything they don't like, the urge to select the best is cancelled out by the equally pressing urge to make the festival as widely representative as possible. This usually leads to the inclusion of what are described as maiden efforts from emergent countries. The jurors, let it be known, are less concerned with effort than with achievement.

Having served on the jury a number of times, I find that I look forward less to the films than to the notion of being part of a group of people – all connected with cinema in various ways – converging from all parts of the world and engaging in a common pursuit. Differences may emerge and heated arguments ensue at the time of deliberation, but seldom at the expense of the camaraderie that has developed through shared responsibility.

With a film in competition one is less trammelled. Those who,

like me, do not suffer from nerves too much can use their time most profitably. It is true that most festivals have lost, or have been forced to shed, some of their glamour. The opening star parade is a thing of the past. But there is no doubt that, with the introduction of parallel festivals with their stress on offbeat, meaningful cinema, along with the inevitable tributes and revivals of classics, the choice of films is wider than ever before.

Apart from the films, there is the delightful occupation of talking shop with fellow film-makers. No matter how widely separated they may be geographically, some mysterious force seems to effect an instant communion between film-makers, so that even before they know each other's names, they may be engrossed in a discussion of the latest Arriflex, or the vagaries of some new zoom lens, or the hazards of shooting on location with a small crew.

Unless he should happen to be his own producer, a film-maker need not embroil himself with the sordid business of trying to sell his own product. In fact, he has only one obligation, which is to be present at his own screening. This is where the question of the audience comes up.

Each of the four or five major film festivals in Europe is marked by its own unique brand of audience. In Moscow, they are polite to the point where they will not only sit through almost anything without a murmur, but applaud heartily at the end. In Berlin, while the rest of the audience observes decorum, a small group at the back will keep hurling invectives at whatever unfolds on the screen. In Venice, if a film is not liked, the audience will pulverize the film-maker with their boos and cat-calls. These go on throughout the screening, reaching a bloodcurdling pitch the moment the spotlight is turned on the director at the end. Since he is already bowed in abject misery, there is no question of the director taking a bow.

The new kind of film festivals, which has come into existence in Britain and the USA in the last ten or fifteen years, is non-exclusive and, coming at the end of the year, these festivals are in a position to show the prize-winners from the European fetes. In addition, there is a handpicked selection usually reflecting the taste of the festival director, plus the usual retrospectives and tributes. London and New York give no prizes, while Chicago and San Francisco do. The audience here consists mostly of film buffs, and the films are noticed by the critics. Prizes or no prizes, good reviews may lead to enquiries from distributors.

I had the good fortune to attend the Chicago Film Festival in 1973. Two cinemas in Chicago at opposite ends of the vast sprawling city had been chosen for the festival screenings. Both showed the competitive entries as well as a series of eight of my films. One of the cinemas was within the campus of the university. I had to go there every day to introduce my films to the students and to answer questions at the end. Altogether a most refreshing change from the routine of the European festivals.

If we are to have international film festivals in India, I firmly believe that they should be planned on the lines of Chicago or San Francisco. Prizes are necessary as a bait to the lesser film-producing countries; and as a sop to our own public, a sprinkling of stars among the invited delegates wouldn't be a bad idea. Finally, and most importantly, the festival should be non-exclusive. In other words, we should have the option to ask for specific films, the highlights from the preceding festivals, as well as the best of recent American and British Cinema which are no longer accessible to us commercially, rather than leave the choice to the producers. It is hard to believe that major foreign producers would earmark their more prestigious productions for India, when as potential market India has so little to offer.

22

OUR FESTIVALS, THEIR FESTIVALS

IF THE QUALITY of films were the sole criterion, surely one of the best film festivals ever held anywhere was the first international film festival in India in 1952. This took place just two months after I had started shooting *Pather Panchali*. I was still in advertising and also very much involved in the running of the Calcutta Film Society, then five years old. As soon as we learnt that the government was planning a film festival, we published in our bulletin a long list of foreign films which we felt should be included in the festival.

We sent a copy of the bulletin to the ministry in Delhi, and I must say that most of what we recommended did eventually turn up. Few festivals before or since have provided such a feast of outstanding films. And mercifully, there were no jurors, no prizes, no seminars, few parties and only a handful of visiting celebrities. The organization consisted primarily of procuring the films and acquiring the theatres to screen them. For the film

The Statesman, 5 January 1982

buffs – present writer included – it meant a steady diet of four feature films a day for a fortnight. We rushed from one cinema to another, barely recovering from the effect of one mighty work before another impinged on our consciousness, reeling at day's end, but fresh the next morning for further adventures.

It would be wrong to say that the first international film festival changed the course of Indian cinema, although one wishes it did. Indian cinema stayed resolutely on the beaten track; but the impression left on the discerning filmgoer was deep and lasting.

Venice, 1957

The first film festival I attended abroad was in Venice in 1957. My film *Aparajito* was an entry in the competitive section. In the same section were films by Akira Kurosawa, Luchino Visconti, Fred Zinnemann and Nicholas Ray. I am being absolutely honest when I say that I had not the slightest hope of winning any prizes.

Technically, *Aparajito* had its rough edges. The editing bore signs of hurry, the sound track was gritty, the images grainy through careless processing, I recall squirming in my seat as I watched the film unfold in the 6,000-seater Grande Salle. It was a formal occasion, and in the balcony sat Henry Fonda, Maria Callas, Toshiro Mifune and a host of celebrities.

The applause in the end suggested that the film had gone down well, warts and all. As I came out of the hall and down the stairs, I heard an usherette exclaiming to another girl that she had just seen *una belle film Indiano*. So the voice of the lay public was approving too.

Although the deliberations of the jury were kept a closely guarded secret, three days before the end of the festival an

elderly journalist whom we knew only by sight sidled up to me while my friend Santi and I sat in a pavement café, and whispered dramatically into my ear 'I can hear the lion's roar!' and ambled off.

In the afternoon of the awards – not a word had leaked out yet – a young girl of pronounced good looks came to our hotel, sought us out and started briefing me on what I had to do on the stage that evening.

'On the stage?' I asked.

'Yes,' she said. 'Your name will be called out and you come up to take the prize.'

'What prize?'

'Leone d'Oro.'

The Golden Lion! I kept my cool with some effort, but Santi sprang up from his seat, embraced the girl and kissed her smack on the lips.

As we came back from the awards, hugging the trophy by turns, and sat down to a late supper in the restaurant, the head waiter brought a bottle of champagne and plunked it down on our table saying, 'On the house, Signor Ray.' Wasted on me, a T.T. . . . but nevertheless an exciting end to one of the most exciting and memorable evenings of my life.

The next festival I attended was exciting too, but for an entirely different reason.

Brussels, 1958

I had just come back from the USA after attending the opening of *Pather Panchali* when I got a phone call from Brussels. It was from M. Ledoux of the Brussels Cinematheque, which was organizing a film festival as part of the 1958 Brussels World Fair. M. Ledoux wanted to know if I would consent to be a member of

the jury which would consist of seven directors who had made a name for themselves in the last few years. 'What would be the jury's function?' I asked. It transpired that some eminent film historians had already prepared a list of what they considered to be the twenty best films of all time. The jury would select ten out of the twenty and rank them in order of merit. I asked what the twenty films were. Ledoux rattled off the names – all handpicked masterworks. I said I was sorry, as I didn't think it was possible to compare, say, *The Gold Rush* with *Potemkin* or *Bicycle Thieves* with *La Grande Illusion*. They belonged to different genres. And in any case, I didn't wish to play ranking games with masterpieces. 'You come here and say what you have just told me,' said M. Ledoux.

Vittorio De Sica
(sketch by Satyajit Ray)

So I went as one of the seven jurors and Brussels turned out to be one of the most memorable festivals I ever attended. Not only for the feast of masterpieces (all twenty were shown and many with their directors in attendance), or for the unique futuristic surroundings of the magnificent cinema built in the heart of the fair, but also for the marathon final meeting of the jury. The other members were Michael Cacoyannis from Greece, Javier Bardem from Spain, Francesco Maselli from Italy, Alexandre Astruc from France, and Sandy Mackendrick and Robert Aldrich from the USA. As it turned out, none shared

my qualms about what we were being asked to do. Ledoux had assured me on the phone that I could state my views and refrain from voting. But I was more anxious to bring the others round to my viewpoint. It was inconceivable that those talented people had all given their ungrudging consent to participating in a childish pastime.

Well, win them over I did, but it took all of six hours. We ruled out ranking, and agreed to name not ten but six films out of the twenty which still had relevance for us film-makers of the mid-twentieth century. To decide on the six took another six hours. It was nearly midnight when we filed out of the conference room and filed into a large auditorium chock-a-block with journalists who waited to hear our verdict. What we had to say was greeted with a long round of applause.

Pleasurable aspect

Films are not the only things that make a film festival. With films come film-makers, film critics, film stars, film producers, and film distributors. The last two are usually seen hanging round the Market Section: festivals are as much occasions for commerce as for art.

Film critics usually come in two breeds: those who take to your work and those who don't. The first make good company; the second you shun.

One of the most pleasurable aspects of a film festival is the contact one makes with film-makers from other parts of the world. This is a global fraternity where instant rapport prevails.

Being on the jury has its drawbacks, though. Not all film-producing countries are noted for the excellence of their products, and those that are don't always send their best films to a festival. As a result, a juror may spend hours wading through indifferent footage while the more worthwhile films play *hors concours*.

Film audience

A word about the film audience. Each festival has its own unique brand of audience. I found the Berlin audience of the 1960s relatively civilized in that it wasn't too vociferous in its condemnation of films it didn't like. The most docile of the film audiences, however, is in Moscow. It will sit through almost anything without a murmur. If this means no boos and catcalls, it also means, unfortunately, no applause – at least not during the run of a film. The Venice audience would greet even small directorial felicities with claps and bravos, rather like an Indian audience at a classical concert *wah-wahing* deftly executed *taan*s. For instance, the flight of pigeons that follows Harihar's death in *Aparajito* brought forth a spontaneous burst of applause in Venice. Conversely, the expression of disapproval was equally spontaneous and unbridled. The normal practice in Venice then was to turn the spotlight on the director in the balcony before the lights came up at the end of the screening. I was present at the screening of an Argentinean film which had been booed right through. As the spotlight came on, the booing rose to a frightening crescendo. I saw the doubled-up director slinking away, but not before the abject misery on his face had been caught by the audience.

New Indian cinema

One feature of many international film festivals in recent years has been the focus on the new Indian cinema. Partly responsible for this are the foreign critics who have been coming to our festivals and commenting favourably in their reports on films in the Indian Panorama. The efforts of our government in this direction have not been inconsiderable. Many of these new films have featured in national awards, and packages have been put

together to be sent out to foreign festivals. Even if our new offbeat film-makers find it hard to get theatres to screen their films at home, they are now fairly certain of exposure abroad through festivals. This has led to sales as well as prizes. As long as the new cinema is able to keep its costs low, and foreign buyers show enough faith in it to pay a decent price, our film-makers can hope to break even from foreign sales alone. However, for the trend to last there must be a steady stream of good films coming from the new film-makers. This is dependent on their economic stability as much as their creative vitality. Lack of the former has been known to sap the latter.

Scrap prizes

Surveying the festival scene at home, the pattern that has been set over the years – competitive festivals in New Delhi alternating with non-competitive ones in shifting venues – was perhaps inevitable in view of the special circumstances obtaining in our country. New Delhi not being a film-producing centre, it can hardly be expected to cater to the ready audience for festivals which is scattered elsewhere. There is an attempt to reach this audience by having the non-competitive festivals rotate between Bombay, Madras, Calcutta and Bangalore. This means that the audience at any single city has to wait eight years before its turn comes. This is hardly satisfactory.

I feel New Delhi should forego its ambition to keep up with the Joneses and do away with prizes. The Golden Peacock, let's face it, simply does not have the same prestige or utility as the grand prizes offered by Berlin, Cannes, Venice and Moscow. A top award from any of these major festivals adds greatly to a film's market value; the Peacock doesn't. What's more, the entries in the competitive section in New Delhi are usually of a

substandard quality. This may on occasion apply to some of the major festivals as well; but isn't it obvious that India being no market for European films, foreign producers are unlikely to earmark their worthier products for New Delhi?

Ideally, prizes should be scrapped. New Delhi should be dropped as a venue and the non-competitive festival retained as an annual event with the venue shifting between four or five film-conscious cities.

Calcutta qualifies

There is no doubt that Calcutta qualifies as one. Almost any cultural event has a ready public here. However, the overriding problem of staging a major film festival in Calcutta is to find enough decent theatres in convenient locations to play the films. There was a time when Calcutta could boast of some of the best designed and best maintained cinemas in India. The same cinemas now have rats scuttling across the floor. The screens are dirty, the projection murky and the acoustics substandard.

Our own experience as film-makers is that however lovingly we may craft a film, our theatres turn them into shoddy products. As a result, the public never really gets a chance to see what we intend them to see. What is even more unfortunate is that the public has ceased to care. If it did, if ever there was a hue and cry over the shabby state of the cinemas, their owners would have had to sit up and take notice.

I understand that eight or nine cinemas which have been acquired by Filmotsav (film festival) will undergo renovation for the purpose. If this happens, it will be a substantial long-term gain for the film-makers and film lovers of Calcutta. For this alone they should be grateful to Filmotsav.

FILMOGRAPHY

PATHER PANCHALI (*Song of the Road*), 1955, 115 mins

'It is true. For one year I was trying to sell the scenario, to peddle it . . . since nobody would buy it, I decided to start anyway, because we wanted some footage to prove that we were not incapable of making films. So I got some money against my insurance policies. We started shooting, and the fund ran out very soon. Then I sold some art books, some records and some of my wife's jewellery. Little trickles of money came, and part of the salary I was earning as art director. All we had to spend on was raw stock, hire of a camera, transport and so on . . . I had nothing more to pawn.' – Satyajit Ray

Production: Government of West Bengal. *Screenplay and Direction:* Satyajit Ray. *Based on a novel by Bibhuti Bhusan Bandyopadhyay.* *Music:* Ravi Shankar. *Photography:* Subrata Mitra. *Art Director:* Bansi Chandragupta. *Editing:* Dulal Dutta. *Sound:* Bhupen Ghosh. *Date of release in India:* 26 August 1955.

CAST

Kanu Banerjee (Harihar), Karuna Banerjee (Sarbajaya), Subir Banerjee (Apu), Uma Dasgupta (Durga), Runki Banerjee (Child Durga), Chunibala Devi (Indir Thakrun), Reba Devi (Sejo Thakrun), Aparna Devi (Nilmoni's wife), Tulsi Chakravarty (Prasanna, schoolteacher), Benoy Mukherjee (Baidyanath Majumdar), Haren Banerjee (Srinivas, the sweet seller), Harimohan Nag (Doctor),

Haridhan Nag (Chakraborty), Nibhanoni Devi (Dasi), Kshirod Roy (Priest), Roma Ganguli (Roma).

AWARDS

President's Gold and Silver medals, New Delhi, 1955

Best Human Document, Cannes Film Festival, 1956

Diploma of Merit, Edinburgh Film Festival, 1956

Vatican Award, Rome Film Festival, 1956

Golden Carbao, Manila Film Festival, 1956

Best Film & Best Director, San Francisco Film Festival, 1957

Selznick Golden Laurel, Berlin Film Festival, 1957

Critics' Award: Best Film of the Year, Stratford (Canada), 1958

Best Film, Vancouver Film Festival, 1958

Cultural Award: Best Foreign Film, New York Film Festival, 1959
Kinema Jumpo Award: Best Foreign Film, Tokyo Film Festival, 1966

Bodil Award: Best Non-European Film of the Year, Denmark Film Festival, 1966

APARAJITO (*The Unvanquished*), 1956, 113 mins

'I was not able to achieve more than 60 per cent of what the script demanded . . . (one of the reasons) being a peculiarly technical one. A camera had just come . . . and it jammed frequently during the shooting in Benares. It became impossible to do more than one take of a scene . . . And then we had to rush through the editing stage . . . because the date of release was getting near. Another problem was that Ravi Shankar should have composed half as much music than he did. There are blank moments as a result. But I find the psychological aspect—the relationship between a growing Apu and his mother— very successful.' – Satyajit Ray

Production: Epic Films. *Screenplay and Direction:* Satyajit Ray. *Based on a novel by Bibhuti Bhusan Bandyopadhyay. Music:* Ravi Shankar. *Photography:* Subrata Mitra. *Art Director:* Bansi Chandragupta. *Editing:* Dulal Dutta. *Sound:* Durgadas Mitra. *Date of release in India:* 11 October 1956.

CAST

Kanu Banerjee (Harihar), Karuna Banerjee (Sarbajaya), Pinaki Sengupta (Apu as a little boy), Smaran Ghosal (Apu as a teenager), Santi Gupta (Lahiri's wife), Ramani Sengupta (Bhabataran), Ranibala (Teli), Sudipta Roy (Nirupama), Ajay Mitra (Anil), Charuprakash Ghosh (Nanda Babu), Subodh Ganguly (Headmaster), Moni Srimani (School Inspector), Hemanta Chatterjee (Professor), Kali Banerjee (Kathak), Lalchand Banerjee (Lahiri), K.S. Pandey (Pandey), Meenaksi Devi (Pandey's wife), Anil Mukherjee (Abinash), Harendra Kumar Chakravarty (Doctor), Bhagnu Palwan (Palwan).

AWARDS

Golden Lion of St. Mark, Venice Film Festival, 1957

Cinema Nuovo Award, Venice Film Festival, 1957

Critics' Award, Venice Film Festival, 1957

Best Film and Best Direction, San Francisco Film Festival, 1958

International Critics' Award, San Francisco Film Festival, 1958

Golden Laurel: Best Foreign Film, USA Film Festival, 1958-59

Selznick Golden Laurel, Berlin Film Festival, 1960

Bodil Award: Best Non-European Film of the Year, Denmark Film Festival, 1967

PARASH PATHAR (*The Philosopher's Stone*), 1958, 95 mins

Production: Promod Lahiri. *Screenplay and Direction:* Satyajit Ray. *Based on a short story by Parasuram (Rajsekhar Basu). Music:* Ravi Shankar.

Photography: Subrata Mitra. *Art Director:* Bansi Chandragupta. *Editing:* Dulal Dutta. *Sound:* Durgadas Mitra. *Date of release in India:* 17 January 1958.

CAST

Tulsi Chakravarty (Paresh Chandra Dutta), Ranibala (Paresh's wife), Kali Banerjee (Priyotosh Henry Biswas), Gangapada Bose (Kachalu), Haridhan Mukherjee (Inspector Chatterjee), Jahar Roy (Bhajahari), Bireswar Sen (Police officer), Moni Srimani (Dr Nandi), Chhabi Biswas, Jahar Ganguly, Pahari Sanyal, Kamal Mitra, Nitish Mukherjee, Subodh Ganguly, Tulsi Lahiri, Amar Mullick (Male guests at cocktail party), Chandrabati Devi, Renuka Roy, Bharati Devi (Female guests at cocktail party).

JALSAGHAR (*The Music Room*), 1958, 110 mins

Production: Satyajit Ray Productions. *Screenplay and Direction:* Satyajit Ray. *Based on a short story by Tarashankar Banerjee. Music:* Ustad Vilayat Khan. *Photography:* Subrata Mitra. *Art Direction:* Bansi Chandragupta. *Editing:* Dulal Dutta. *Sound:* Durgadas Mitra. *Date of release in India:* 10 October 1958.

CAST

Chhabi Biswas (Biswambhar Roy), Padma Devi (Mahamaya, his wife), Pinaki Sengupta (Bireswar, his son), Gangapada Bose (Mahim Ganguly), Tulsi Lahiri (Taraprasanna, manager of Biswambhar's estate), Kali Sarkar (Ananta, cook), Wahed Khan (Ustad Uzir Khan), Roshan Kumari (Krisna Bai).

AWARDS

President's Silver Medal, New Delhi, 1959

Award for Best Music, Moscow Film Festival, 1959

APUR SANSAR (*The World of Apu*), 1959, 106 mins

Production: Satyajit Ray Productions. *Screenplay and Direction:* Satyajit Ray. *Based on a part of* Aparajito, *a novel by Bibhuti Bhusan Bandyopadhyay. Music:* Ravi Shankar. *Photography:* Subrata Mitra. *Art Director:* Bansi Chandragupta. *Editing:* Dulal Dutta. *Sound:* Durgadas Mitra. *Date of release in India:* 1 May 1959.

CAST

Soumitra Chatterjee (Apu), Sharmila Tagore (Aparna), Alok Chakravarty (Kajal), Swapan Mukherjee (Pulu), Dhiresh Majumdar (Apu's father-in-law), Sefalika Devi (mother-in-law), Dhiren Ghosh (Landlord), Tusar Banerjee (Groom).

AWARDS

President's Gold Medal, New Delhi, 1959

Sutherland Trophy for Best Original and Imaginative Film, London Film Festival, 1960

Diploma of Merit, XIV International Film Festival, Edinburgh, 1960

Best Foreign Film, National Board of Review of Motion Pictures, USA, 1960

Besides, each film of the Apu Trilogy (*Pather Panchali*, *Aparajito* and *Apur Sansar*) received the Wington Award at the London Film Festival in 1980

DEVI (*The Goddess*), 1960, 93 mins

Production: Satyajit Ray Productions. *Screenplay and Direction:* Satyajit Ray. *Based on a short story by Prabhat Kumar Mukherjee. Music:* Ustad Ali Akbar Khan. *Photography:* Subrata Mitra. *Art Direction:* Bansi Chandragupta. *Editing:* Dulal Dutta. *Sound:* Durgadas Mitra. *Date of release in India:* 19 February 1960.

CAST

Chhabi Biswas (Kalikinkar Roy), Soumitra Chatterjee (Umaprasad, his younger son), Purnendu Mukherjee (Taraprasad, his elder son), Sharmila Tagore (Dayamoyee, Umaprasad's wife), Karuna Banerjee (Harasundari, Taraprasad's wife), Arpan Chakravarty (Khoka, child), Anil Chatterjee (Bhudeb), Kali Sarkar (Professor Sarkar), Mohammed Israil (Nibaran), Khagesh Chakravarty (Kaviraj), Nagendranath Kabya-byakaran-tirtha (Priest), Santa Devi (Sarala).

AWARDS

President's Gold Medal, New Delhi, 1961

TEEN KANYA (*Three Daughters*), 1961, 171 mins

Production: Satyajit Ray Productions. *Screenplay, Music and Direction:* Satyajit Ray. *Based on three short stories by Rabindranath Tagore.* *Photography:* Soumendu Roy. *Art Direction:* Bansi Chandragupta. *Editing:* Dulal Dutta. *Sound:* Durgadas Mitra. *Date of release in India:* 5 May 1961.

THE POSTMASTER, 56 mins

CAST

Anil Chatterjee (Nandalal), Chandana Banerjee (Ratan), Nripati Chatterjee (Bishu, the crazy), Khagen Pathak (Khagen), Gopal Roy (Bilas).

MONIHARA (*The Lost Jewels*), 59 mins

CAST

Kali Banerjee (Phanibhusan Saha), Kanika Majumdar (Manimalika),

Kumar Roy (Madhusudan), Gobinda Chakraborty (Schoolmaster and narrator).

SAMAPTI (*The Conclusion*), 56 mins

CAST

Soumitra Chatterjee (Amulya), Aparna Dasgupta (Mrinmoyee), Sita Mukherjee (Jogamaya), Gita Dey (Nistarini), Mihir Chakraborty (Rakhal), Debi Neogy (Haripada), Santosh Dutta (Nirupama's Father).

AWARDS

President's Silver Medal, New Delhi, 1961 (*Samapti*)

Golden Boomerang, Melbourne, 1962 (*Samapti* and *The Postmaster*)

Selznick Golden Laurel Award, Berlin, 1963

RABINDRANATH TAGORE, 1961, 54 mins

This documentary film deals with the life and work of the celebrated Bengali author Rabindranath Tagore (1861-1941) who was awarded the Nobel Prize for Literature in 1913. The first section is composed of dramatized vignettes recalling the writer's childhood and adolescence: his private, domestic life. The second section, drawn from archived documents, shows his public life, emphasizing the great political movements in which he was engaged, and which led to India's independence.

Production: Films Division, Government of India. *Screenplay, Narration and Direction:* Satyajit Ray. *Art Director:* Bansi Chandragupta. *Photography:* Soumendu Roy. *Music:* Jyotirindra Moitra. *Editing:* Dulal Dutta. *Sound:* Satyen Chatterjee, Durgadas Mitra. *Song and Dance:* Gitabitan.

CAST

Raya Chatterjee, Sovanlal Ganguli, Smaran Ghosal, Purnendu Mukherjee, Kallol Bose, Subir Bose, Phani Nan, Norman Ellis.

AWARDS

President's Gold Medal, New Delhi, 1961

Golden Seal, Locarno, 1961

Special Mention, Montevideo, 1962

KANCHENJUNGHA, 1962, 102 mins

Production: N.C.A. Productions. *Original screenplay, Music and Direction:* Satyajit Ray. *Photography:* Subrata Mitra. *Art Director:* Bansi Chandragupta. *Editing:* Dulal Dutta. *Sound:* Durgadas Mitra. *Date of release in India:* 19 May 1962.

CAST

Chhabi Biswas (Indranath Roy), Anil Chatterjee (Anil), Karuna Banerjee (Labanya), Anubha Gupta (Anima), Subrata Sen (Sankar), Sibani Singh (Tuklu), Alakananda Roy (Manisa), Arun Mukherjee (Ashok), N. Viswanathan (Mr Banerjee), Pahari Sanyal (Jagadish), Nilima Chatterjee, Vidya Sinha (Girlfriends of Anil).

ABHIJAN (*The Expedition*), 1962, 150 mins

Production: Abhijatrik. *Screenplay, Music and Direction:* Satyajit Ray. *Based on a story by Tarashankar Banerjee. Photography:* Soumendu Roy. *Art Director:* Bansi Chandragupta. *Editing:* Dulal Dutta. *Sound:* Durgadas Mitra, Nripen Paul, Sujit Sarkar. *Date of release in India:* 24 September 1962.

CAST

Soumitra Chatterjee (Narsing), Waheeda Rehman (Gulabi), Ruma Guha Thakurta (Neeli), Jnanesh Mukherjee (Joseph), Charuprakash Ghosh (Sukhanram), Rabi Ghosh (Rama), Arun Roy (Naskar), Shekhar Chatterjee (Rameswar), Ajit Banerjee (Banerjee), Reba Devi (Joseph's mother), Abani Mukherjee (Lawyer).

AWARDS

President's Silver Medal, New Delhi, 1962

MAHANAGAR (*The Big City*), 1963, 131 mins

Production: R.D.B. and Co. (R.D. Bansal). *Screenplay, Music and Direction:* Satyajit Ray. *From the short story 'Abataranika' by Narendranath Mitra. Photography:* Subrata Mitra. *Art Director:* Bansi Chandragupta. *Editing:* Dulal Dutta. *Sound:* Debesh Ghosh, Atul Chatterjee, Sujit Sarkar. *Date of release in India:* 27 September 1963.

CAST

Anil Chatterjee (Subrata Mazumdar), Madhabi Mukherjee (Arati Mazumdar), Jaya Bhaduri (Bani), Haren Chatterjee (Priyagopal, Subrata's father), Sefalika Devi (Sarojini, Subrata's mother), Prasenjit Sarkar (Pintu), Haradhan Banerjee (Himangsu Mukherjee), Vicky Redwood (Edith).

AWARDS

Certificate of Merit, New Delhi, 1964

Silver Bear for Best Direction, Berlin, 1964

CHARULATA (*The Lonely Wife*), 1964, 117 mins

Production: R.D. Bansal & Co. *Screenplay, Music and Direction:* Satyajit Ray. *Based on the story, 'Nastoneer', by Rabindranath Tagore. Photography:* Subrata Mitra. *Art Director:* Bansi Chandragupta. *Editing:* Dulal Dutta. *Sound:* Nripen Paul, Atul Chatterjee, Sujit Sarkar. *Date of release in India:* 17 April 1964.

CAST

Soumitra Chatterjee (Amal), Madhabi Mukherjee (Charu), Sailen Mukherjee (Bhupati), Shyamal Ghosal (Umapada), Gitali Roy (Mandakini), Bholanath Koyal (Braja), Suku Mukherjee (Nisikanta), Dilip Bose (Sasanka), Subrata Sen Sharma (Motilal), Nilotpal Dey (Joydeb), Bankim Ghosh (Jagannath).

AWARDS

President's Gold Medal, New Delhi, 1964

Silver Bear for Best Direction, Berlin Film Festival, 1965

Catholic Award, Berlin Film Festival, 1965

Best Film, Acapulco Film Festival, 1965

TWO, 1964, 16 mins

This short film shows an encounter, through a series of games, between a street child from the shantytowns and a child of a rich family, stationed at his window. The film has no dialogue and the action moves through the attempts at one-upmanship evident in their successive display of their toys. Their rivalry (a kite shot down by a toy rifle, for example) concludes with the opposition between the world of noise (the toys inside the house) and that of music (the street child's flute).

Production: Esso World Theatre. *Story, Screenplay, Music and Direction:* Satyajit Ray. *Photography:* Soumendu Roy. *Art Director:* Bansi Chandragupta. *Editing:* Dulal Dutta. *Sound:* Sujit Sarkar

CAST

Ravi Kiran

KAPURUSH-O-MAHAPURUSH
(*The Coward and the Holy Man*), 1965, 139 mins

Production: R.D.B. and Co. (R. D. Bansal). *Screenplay, Music and Direction:* Satyajit Ray. *From the short story 'Janaiko Kapurusher Kahini' by Premendra Mitra and the short story 'Birinchi Baba' by Parasuram.* *Photography:* Soumendu Roy. *Art Director:* Bansi Chandragupta. *Editing:* Dulal Dutta. *Sound:* Nripen Paul, Atul Chatterjee, Sujit Sarkar. *Date of release in India:* 7 May 1965.

CAST

Kapurush, 74 mins: Soumitra Chatterjee (Amitava Roy), Madhabi Mukherjee (Karuna Gupta), Haradhan Banerjee (Bimal Gupta).

Mahapurush, 65 mins: Charuprakash Ghosh (Birinchi Baba), Rabi Ghosh (His assistant), Prasad Mukherjee (Gurupada Mitter), Gitali Roy (Buchki), Satindra Bhattacharya (Satya), Somen Bose (Nibaran), Santosh Dutta (Professor Nani), Renuka Roy (Nani's wife).

NAYAK (*The Hero*), 1966, 120 mins

Production: R.D. Bansal & Co. *Original screenplay, Music and Direction:* Satyajit Ray. *Photography:* Subrata Mitra. *Art Director:* Bansi Chandragupta. *Editing:* Dulal Dutta. *Sound:* Nripen Paul, Atul Chatterjee, Sujit Sarkar. *Date of release in India:* 6 May 1966.

CAST

Uttam Kumar (Arindam Mukherjee), Sharmila Tagore (Aditi Sen Gupta), Bireswar Sen (Mukunda Lahiri), Somen Bose (Sankar), Nirmal Ghosh (Jyoti), Premangsu Bose (Biresh), Sumita Sanyal (Promila), Ranjit Sen (Mr Bose), Bharati Devi (Manorama, his wife), Lali Chowdhury (Bulbul, his daughter), Kamu Mukherjee (Pritish Sarkar), Susmita Mukherjee (Molly, his wife), Subrata Sen Sharma (Ajoy), Jamuna Sinha (Sefalika, his wife), Hiralal (Kamal Misra), Jogesh Chatterjee (Aghore, elderly journalist), Satya Banerjee (Swamiji), Gopal Dey (Conductor).

AWARDS

Best Screenplay and Story, New Delhi, 1967

Critics' Prize and Special Jury Award, Berlin, 1966

CHIRIAKHANA (*The Zoo*), 1967, 125 mins

Production: Star Productions (Harendranath Bhattacharya). *Screenplay, Music and Direction:* Satyajit Ray. *Based on the novel* Chiriakhana *by Saradindu Banerjee. Photography:* Soumendu Roy. *Art Director:* Bansi Chandragupta. *Editing:* Dulal Dutta. *Sound:* Nripen Paul, Atul Chatterjee, Sujit Sarkar. *Date of release in India:* 29 September 1967.

CAST

Uttam Kumar (Byomkesh Bakshi), Salien Mukherjee (Ajit), Susil Majumdar (Nisanath Sen), Kanika Majumdar (Damyanti, his wife), Subhendu Chatterjee (Bijoy), Shyamal Ghosal (Dr Bhujagandhar Das), Prasad Mukherjee (Nepal Gupta), Subira Roy (Mukul, his daughter), Nripati Chatterjee (Muskil Mia), Gitali Roy (Banalakshmi), Kalipada Chakravarti (Rasiklal), Chinmoy Roy (Panugopal), Ramen Mullick (Jahar Ganguli), Brajadas (Bankim Ghosh), Nilotpal Dey (Inspector).

AWARDS

Best Direction, West Bengal Government, 1968

GOOPY GYNE BAGHA BYNE
(*The Adventures of Goopy and Bagha*), 1968, 132 mins

Production: Purnima Pictures (Nepal Dutta, Asim Dutta). *Screenplay, Music and Direction:* Satyajit Ray. *From the story by Upendrakisore Ray. Photography:* Soumendu Roy. *Art Director:* Bansi Chandragupta. *Editing:* Dulal Dutta. *Sound:* Nripen Paul, Atul Chatterjee, Sujit Sarkar. *Date of release in India:* 8 May 1969.

CAST

Tapen Chatterjee (Goopy), Rabi Ghosh (Bagha), Santosh Dutta (King of Shundi/King of Halla), Jahar Roy (Prime Minister of Halla), Santi Chatterjee (Commander-in-chief of Halla), Harindranath Chatterjee (Barfi, magician), Chinmoy Roy (Spy of Halla), Durgadas Banerjee (King of Amloki), Gobinda Chakravarti (Goopy's father), Prasad Mukherjee (King of Ghosts), Haridhan Mukherjee, Abani Chatterjee, Khagen Pathak, Binoy Basu (Village elders), Joykrishna Sanyal, Tarun Mitra, Ratan Banerjee, Kartik Chatterjee (Singers at the court of Shundi), Gopal Dey (Executioner), Ajoy Banerjee, Sailen Ganguli, Moni Srimani, Binoy Bose, Kartik Chatterjee (Visitors to Halla).

AWARDS

President's Gold and Silver Medals, New Delhi, 1970

Silver Cross Award, Best Direction and Originality, Adelaide and Auckland, 1969

Merit Award, Tokyo, 1970

Best Film, Melbourne, 1970

ARANYER DIN RATRI (*Days and Nights in the Forest*), 1969, 115 mins

Production: Nepal Dutta and Asim Dutta for Purnima Pictures. *Screenplay, Music and Direction:* Satyajit Ray. *Based on a novel by Sunil Gangopadhyay. Photography:* Soumendu Roy. *Art Direction:* Bansi Chandragupta. *Editing:* Dulal Dutta. *Sound:* Sujit Sarkar. *Date of release in India:* 16 January 1970.

CAST

Soumitra Chatterjee (Asim), Subhendu Chatterjee (Sanjoy), Samit Bhanja (Harinath), Rabi Ghosh (Sekhar), Pahari Sanyal (Sadasiv Tripathy), Sharmila Tagore (Aparna), Kaveri Bose (Jaya), Simi Garewal (Duli), Aparna Sen (Atasi).

PRATIDWANDI (*The Adversary*), 1970, 110 mins

Production: Nepal Dutta and Asim Dutta for Purnima Pictures. *Screenplay, Music and Direction:* Satyajit Ray. *Based on a novel by Sunil Gangopadhyay. Photography:* Soumendu Roy, Purnendu Bose. *Art Direction:* Bansi Chandragupta. *Editing:* Dulal Dutta. *Sound:* J.D. Irani, Durgadas Mitra. *Date of release in India:* 29 October 1970.

CAST

Dhritiman Chaterji (Siddhartha Chaudhuri), Indira Devi (Sarojini), Debraj Roy (Tunu), Krishna Bose (Sutapa), Kalyan Chatterjee (Shiben), Joyshree Roy (Keya), Sefali (Lotika), Soven Lahiri (Sanyal), Pisu Majumdar (Keya's father), Dhara Roy (Keya's aunt), Mamata Chatterjee (Sanyal's wife).

AWARDS

President's Silver Medal, New Delhi, 1971

President's Special Award, New Delhi, 1971
President's Award for Best Direction, New Delhi, 1971

SEEMABADDHA (*Company Limited*), 1971, 112 mins

Production: Bharat Shamsher Jung Bahadur Rana for Chitranjali.
Screenplay, Music, Direction: Satyajit Ray. *Based on a novel by Shankar.*
Photography: Soumendu Roy. *Art Direction:* Ashoke Bose. *Editing:*
Dulal Dutta. *Sound:* J.D. Irani, Durgadas Mitra. *Date of release in India:*
24 September 1971.

CAST

Barun Chanda (Shyamal Chatterjee), Sharmila Tagore (Sudarsana,
known as Tutul), Paromita Chaudhuri (Shyamal's wife),
Harindranath Chattopadhyay (Sir Baren Roy), Haradhan Banerjee
(Talukdar), Indira Roy (Shyamal's mother), Pramod Ganguli
(Shyamal's father).

AWARDS

President's Gold Medal, New Delhi, 1972
FIPRESCI Award, Venice Film Festival, 1972

SIKKIM, 1971, 52 mins

This documentary, officially commissioned by the Chogyal of Sikkim,
intends to show what life in this country was like. The film has suffered
a double censorship: that of the film's commissioners, who cut out
some images that they found disagreeable; and that of the Indian
government, which looked askance at these images dedicated to a
monarchy, when Sikkim was reconnected to India in 1975. Notably

suppressed is the moment when we see the crowd prostrating itself in front of the ruler.

Producer: The Chogyal of Sikkim. *Script, Music, Narration and Direction:* Satyajit Ray. *Photography:* Soumendu Roy. *Editing:* Dulal Dutta. *Sound:* Amulya Das.

THE INNER EYE, 1972, 19 mins

A documentary homage to a painter at work. Benode Bihari Mukherjee lost his sight following a cataract surgery. Ray had been his student when he was at Santiniketan, the university founded by Tagore.

Production: Films Division, Government of India. *Screenplay, Music, Narration and Direction:* Satyajit Ray. *Photography:* Soumendu Roy. *Editing:* Dulal Dutta. *Sound:* J.D. Irani, Durgadas Mitra.

AWARDS

Prime Minister's Gold Medal, New Delhi, 1972

ASHANI SANKET (*Distant Thunder*), 1973, 101 mins

Production: Sarbani Bhattacharya for Balaka Movies. *Screenplay, Music and Direction:* Satyajit Ray. *Based on a novel by Bibhuti Bhusan Bandyopadhyay. Photography:* Soumendu Roy. *Art Direction:* Ashoke Bose. *Editing:* Dulal Dutta. *Sound:* J.D. Irani, Durgadas Mitra. *Date of release:* 15 August 1973.

CAST

Soumitra Chatterjee (Gangacharan Chakraborti), Babita (Ananga,

Gangacharan's wife), Ramesh Mukherjee (Biswas), Chitra Banerjee (Moti), Gobinda Chakraborti (Dinabandhu), Sandhya Roy (Chhutki), Noni Ganguli (Scarfaced Jadu), Sheli Pal (Mokshada), Suchita Roy (Khenti), Anil Ganguly (Nibaran), Debatosh Ghosh (Adhar).

AWARDS

Golden Bear, Berlin Film Festival, 1973

President's Gold Medal for Music, New Delhi, 1973

President's Award for Best Colour Photography, Soumendu Roy, New Delhi, 1973

President's Award for Best Bengali Film, New Delhi, 1973

Best Film, Government of West Bengal, 1973

Best Actor, Soumitra Chatterjee, Government of West Bengal, 1973

SONAR KELLA (*The Golden Fortress*), 1974, 120 mins

Production: The Government of West Bengal. *Screenplay, Music and Direction:* Satyajit Ray. *Based on a novel by Satyajit Ray. Art Direction:* Ashoke Bose. *Editing:* Dulal Dutta. *Sound:* J.D. Irani, Anil Talukdar. *Date of release in India:* 17 December 1974.

CAST

Soumitra Chatterjee (Prodosh 'Felu' Mitter), Santosh Dutta (Lalmohan Ganguli, 'Jatayu'), Siddhartha Chatterjee (Tapesh Mitter, known as Topse), Kushal Chakravarti (Mukul Dhar), Sailen Mukherjee (Dr Hemanga Hazra), Ajoy Banerjee (Amiyanath Burman), Kamu Mukherjee (Mandar Bose), Santanu Bagchi (Mukul 2), Harindranath Chattopadhyay (Uncle Sidhu), Sunil Sarkar (Sudhir Dhar, Mukul's father), Shiuli Mukherjee (Mukul's mother), Haradhan Banerjee (Tapesh's father), Rekha Chatterjee (Tapesh's mother), Ashok Mukherjee (Journalist), Bimal Chatterjee (Advocate).

AWARDS

Government of West Bengal Award for Best Film and Best Director, 1974

President's Silver Medal, New Delhi, 1974

Best Colour Photography, Best Director, Best Screenplay, New Delhi, 1974

Golden Statue for 'Best Live Feature Film', Tenth Teheran International Festival of Films for Children and Young Adults, 1975

JANA ARANYA (*The Middle Man*), 1975, 131 mins

Production: Indus Films (Subir Guha). *Screenplay, Music and Direction:* Satyajit Ray. *Based on the novel* Jana Aranya *by Sankar. Photography:* Soumendu Roy. *Art Director:* Ashok Bose. *Editing:* Dulal Dutta. *Sound:* J.D. Irani, Anil Talukdar, Sujit Ghosh, Adinath Nag. *Date of release in India:* 20 February 1976.

CAST

Pradip Mukherjee (Somnath Banerjee), Satya Banerjee (Somnath's father), Dipankar Dey (Bhombol), Lily Chakravarti (Kamala, his wife), Aparna Sen (Somnath's girlfriend), Gautam Chakravarti (Sukumar), Sudesna Das (Kauna, known as Juthika), Utpal Dutta (Bisu), Rabi Ghosh (Mr Mitter), Bimal Chatterjee (Alok), Arati Bhattacharya (Mrs Ganguli), Padma Devi (Mrs Biswas), Soven Lahiri (Goenka), Santosh Dutta (Hiralal), Bimal Deb (Jagabandhu, MLA/MP), Ajeya Mukherjee (Pimp), Kalyan Sen (Mr Bakshi), Alokendu Dey (Fakirchand, office bearer).

AWARDS

Best Direction, New Delhi, 1975

Best Film, Direction, Screenplay, West Bengal Government, 1975

Karlovy Vary Prize, 1976

BALA, 1975, 33 mins

Production: National Centre for the Performing Arts, Bombay, and Government of Tamil Nadu. *Script, Commentary and Music:* Satyajit Ray. *Editor:* Dulal Dutta. *Sound:* S.P. Ramanathan, Sujit Sarkar, David. *Photography:* Soumendu Roy.

SHATRANJ KE KHILARI (*The Chess Players*), 1977, 113 mins

Production: Suresh Jindal for Devaki Chitra. *Screenplay, Music and Direction:* Satyajit Ray. *Based on a story by Munshi Premchand. Dialogue:* Satyajit Ray, Shama Zaidi, Javed Siddiqui. *Art Director:* Bansi Chandragupta. *Associate Art Director:* Ashok Bose. *Costumes:* Shama Zaidi. *Photography:* Soumendu Roy. *Editing:* Dulal Dutta. *Sound:* Narinder Singh. *Date of release in India:* 29 September 1978.

CAST

Sanjeev Kumar (Mirza Sajjad Ali), Saeed Jaffrey (Mir Roshan Ali), Amjad Khan (Wajid Ali Shah), Richard Attenborough (General Outram), Shabana Azmi (Khurshid), Farida Jalal (Nafeesa), Veena (Aulea Begum, Queen Mother), David Abraham (Munshi Nandlal), Victor Banerjee (Ali Naqi Khan, Prime Minister), Farooque Shaikh (Aqil), Tom Alter (Captain Weston), Leela Mishra (Hiria), Barry John (Dr Joseph Fayrer), Samrath Narain (Kalloo), Budho Advani (Imtiaz Hussain), Kamu Mukherjee (Bookie).

AWARDS

Best Feature Film in Hindi, New Delhi, 1977

Best Colour Photography, Soumendu Roy, New Delhi, 1977

JOI BABA FELUNATH (*The Elephant God*), 1978, 112 mins

Production: R.D.B. and Co. (R.D. Bansal). *Screenplay, Music and Direction:* Satyajit Ray. *Based on the novel* Joi Baba Felunath *by Satyajit Ray. Photography:* Soumendu Roy. *Art Director:* Ashok Bose. *Editing:* Dulal Dutta. *Sound:* Robin Sen Gupta. *Date of release in India:* 5 January 1979.

CAST

Soumitra Chatterjee (Pradosh Mitter, 'Feluda'), Santosh Dutta (Lalmohan Ganguli, 'Jatayu'), Siddhartha Chatterjee (Tapesh Mitter, 'Topshe'), Utpal Dutta (Maganlal Meghraj), Jit Bose (Ruku Ghoshal), Haradhan Banerjee (Umanath Ghoshal), Bimal Chatterjee (Ambika Ghoshal), Biplab Chatterjee (Bikash Sinha), Satya Banerjee (Nibaran Chakravarti), Moloy Roy (Gunomoy Bagchi), Santosh Sinha (Sasi Pal), Manu Mukherjee (Machli Baba), Indubhushan Gujral (Inspector Tiwari), Kamu Mukherjee (Arjun).

AWARDS

Best Children's Film, New Delhi, 1978

HIRAK RAJAR DESHE (*The Kingdom of Diamonds*), 1980, 118 mins

Production: Government of West Bengal. *Original screenplay, Music and Direction:* Satyajit Ray. *Photography:* Soumendu Roy. *Art Director:* Ashok Bose. *Editing:* Dulal Dutta. *Sound:* Robin Sen Gupta, Durgadas Mitra. *Date of release in India:* 19 December 1980.

CAST

Soumitra Chatterjee (Udayan, the schoolteacher), Utpal Dutta (King Hirak), Tapen Chatterjee (Goopy), Rabi Ghosh (Bagha), Santosh Dutta (King of Shundi/Gabesak, inventor), Promod Ganguli

(Udayan's father), Alpana Gupta (Udayan's mother), Rabin Majumdar (Charandas), Sunil Sarkar (Fazl Mia), Nani Ganguli (Balaram), Ajoy Banerjee (Bidusak), Kartik Chatterjee (Court poet), Haridhan Mukherjee (Court astrologer), Bimal Deb, Tarun Mitra, Gopal Dey, Salien Ganguli, Samir Mukherjee (Ministers).

PIKOO, 1980, 26 mins

Production: Henri Fraise. *Screenplay, Music and Direction:* Satyajit Ray. *From the short story 'Pikur Diary' by Satyajit Ray. Photography:* Soumendu Roy. *Art Director:* Ashok Bose. *Editing:* Dulal Dutta. *Sound:* Robin Sen Gupta, Sujit Sarkar.

CAST

Arjun Guha Thakurta (Pikoo), Aparna Sen (Seema, his mother), Soven Lahiri (Ranjan), Promod Ganguli (Grandfather Loknath), Victor Banerjee (Uncle Hitesh).

SADGATI (*Deliverance*), 1981, 52 mins

Production: Doordarshan. *Screenplay, Music and Direction:* Satyajit Ray. *Based on a story by Munshi Premchand. Photography:* Soumendu Roy. *Art Direction:* Ashok Bose. *Editing:* Dulal Dutta. *Sound:* Amulya Das.

CAST

Om Puri (Dukhi Chamar), Smita Patil (Jhuria, his wife), Mohan Agashe (Ghasiram), Richa Misra (Dukhi's daughter), Gita Siddharth (Lakshmi, Ghasiram's wife), Bhaiyalal Hedau (The Gond).

AWARDS

Special Jury Award, New Delhi, 1981

GHARE BAIRE (*The Home and the World*), 1984, 140 mins

Production: National Film Development Corporation of India. *Screenplay, Music and Direction:* Satyajit Ray. *Based on the novel* Ghare Baire *by Rabindranath Tagore. Art Director:* Ashok Bose. *Photography:* Soumendu Roy. *Editing:* Dulal Dutta. *Sound:* Robin Sen Gupta, Jyoti Chatterjee, Anup Mukherjee. *Date of release in India:* 4 January 1985.

CAST

Soumitra Chatterjee (Sandip), Victor Banerjee (Nikhilesh), Swatilekha Chatterjee (Bimala), Gopa Aich (Nikhilesh's sister-in-law), Jennifer Kapoor (Miss Gilby), Manoj Mitra (Headmaster), Indrapramit Roy (Amulya), Bimal Chatterjee (Kulada).

SUKUMAR RAY, 1987, 30 mins

Production: Government of West Bengal. *Script, Music and Direction:* Satyajit Ray. *Commentary:* Soumitra Chatterjee. *Photography:* Barun Raha. *Editing:* Dulal Dutta. *Sound:* Sujit Sarkar.

CAST

Soumitra Chatterjee, Utpal Dutta, Santosh Dutta, Tapen Chatterjee.

GANASATRU (*An Enemy of the People*), 1989, 100 mins

Production: National Film Development Corporation of India. *Screenplay, Music and Direction:* Satyajit Ray. *Based on the play* An Enemy of the People *by Henrik Ibsen. Art Director:* Ashok Bose. *Photography:* Barun Raha. *Editing:* Dulal Dutta. *Sound:* Sujit Sarkar. *Date of release in India:* 19 January 1990.

CAST

Soumitra Chatterjee (Dr Ashok Gupta), Ruma Guha Thakurta (Maya, his wife), Mamata Shankar (Indrani, his daughter), Dhritiman Chaterji (Nisith), Dipankar Dey (Haridas Bagchi), Subhendu Chatterjee (Biresh), Manoj Mitra (Adhir), Viswa Guha Thakurta (Ranen Haldar), Rajaram Yagnik (Bhargava), Satya Banerjee (Manmatha), Gobindo Mukherjee (Chandan).

SHAKHA PROSHAKHA (*Branches of a Tree*), 1990, 120 mins

Production: Satyajit Ray Productions (Calcutta), Erato Films (Paris), D.D. Productions (Paris). *Story, Original screenplay, Music and Direction:* Satyajit Ray. *Photography:* Barun Raha. *Art Director:* Ashok Bose. *Editing:* Dulal Dutta. *Sound:* Pierre Lenoir. *Date of release (on Doordarshan channel) in India*: 5 May 1991.

CAST

Soumitra Chatterjee (Proshanto), Ranjit Mallick (Pratap), Dipankar Dey (Prabir), Haradhan Banerjee (Prabodh), Mamata Shankar (Tapati), Lily Chakraborty (Uma), Ajit Banerjee (Anandamohan), Master Soham Chakraborty (Dingo), Viswa Guha Thakurta (Dr Ashok De), Kamu Mukherjee (Ramdohin), Rajaram Yagnik (Dr Sahay), Pradip Mukherjee (Bijan, journalist), Sunil Guptakabiraj (Dr Som), Ashoke Mukherjee (Joydeb), Tarun Mitra (President).

AGANTUK (*The Stranger*), 1991, 119 mins

Production: National Film Development Corporation of India. *Screenplay, Music and Direction:* Satyajit Ray. *Based on the story 'Atithi' by Satyajit Ray. Photography:* Barun Raha. *Art Direction:* Ashok Bose. *Editing:* Dulal Dutta. *Sound:* Sujit Sarkar. *Date of release in India:* 20 December 1991.

CAST

Dipankar Dey (Sudhindra Bose), Mamata Shankar (Anila Bose), Bikram Bhattacharya (Satyaki/Bablu), Utpal Dutta (Manomohan Mitra), Dhritiman Chaterji (Prithwish Sengupta), Rabi Ghosh (Ranjan Rakshit), Subrata Chatterjee (Chhanda Rakshit), Pramode Ganguli (Tridib Mukherjee), Ajit Banerjee (Sital Sarkar).

AWARDS

FIPRESCI Award, Venice Film Festival, 1991

Best Film, New Delhi, 1991

Best Director, New Delhi, 1991

SATYAJIT RAY'S CONTRIBUTIONS TO FILMS OTHER THAN HIS OWN

Ray wrote the screenplays of such documentaries and advertisement films directed by Harisadhan Dasgupta as *A Perfect Day* (1948), *Our Children Will Know Each Other Better* (1960), *The Story of Tata Steel* (1961), and *The Brave Do not Die* (1978).

He scored the music for *Shakespearewallah* (1965), directed by James Ivory, and *Quest for Health* (1967), an advertisement film, directed by Harisadhan Dasgupta.

Ray has also scored the music for *Glimpses of West Bengal* (1967), *Gangasagar Mela* (1974), and *Darjeeling: Himalayan Fantasy* (1974) directed by Bansi Chandragupta, and *House that Never Dies* (1969), directed by Tony Meyer.

Ray wrote the screenplay and scored the music for *Baksa Badal* (1965), directed by Nityananda Dutta.

Ray lent his voice for the commentary of *Tidal Bore*, directed by Vijay Mulay, and *Max Mueller* (1973), directed by Jorn Thiel. He also scored the music for *Max Mueller*.

Satyajit Ray's contributions to his son Sandip Ray's initial forays into film-making were instrumental in establishing the latter's cinematic career.

Sandip Ray based his first feature film, *Phatikchand* (*Phatik and the Juggler*, 1983), on a story by his father. Ray wrote the screenplay and

scored the music for the film. Ray also scored the music for Sandip's 1991 film *Goopy Bagha Phire Elo* (*The Return of Goopy and Bagha*).

Later, Sandip based two other feature films on screenplays done by Ray, *Uttaran* (*The Broken Journey*, 1993) and *Target* (1995). He based four full-length feature films, *Bombaier Bombete* (*Bandits from Bombay*, 2003), *Kailase Kelenkari* (*Trouble at Kailas*, 2007), *Tintorettor Jishu* (*Jesus by Tintoretto*, 2008) and *Gorosthane Sabdhan* (*Beware at the Graveyard*, 2010) on Ray's Feluda novels.

Besides, Sandip based a large number of his TV films on Ray stories. They include *Satyajit Ray Presents* (1985-86), containing 13 films; *Satyajit Ray Presents II* (1986-87), containing three films; *Feluda 30* (1996-97), containing five films; *Satyajiter Gappo* (*Stories by Satyajit*, 1999), containing four films; *Dr Munshir Diary* (*Dr Munshi's Diary*, 2000); *Satyajiter Priyo Galpo* (*Satyajit's Favourite Stories*, 2001), containing seven stories; and *Eker Pithe Dui* (*2 Upon 1*, 2001), containing 12 stories.

AWARDS WON BY SATYAJIT RAY

Awards conferred on Satyajit Ray, by both Indian and international organizations, include:

1958 : Padmashree, India

1965 : Padmabhushan, India

1967 : Magsaysay Award, Manila

1971 : Star of Yugoslavia

1973 : Doctor of Letters, Delhi University

1974 : D. Litt., Royal College of Arts, London

1976 : Padma Vibhushan, India

1978 : D. Litt., Oxford University; Special Award, Berlin Film Festival; Deshikottam, Visva-Bharati University, India

1979 : Special Award, Moscow Film Festival

1980 : D. Litt., Burdwan University, India; D. Litt., Jadavpur University, India

1981 : Doctorate, Benaras Hindu University, India; D. Litt., North Bengal University, India

1982 : Hommage à Satyajit Ray, Cannes Film Festival; Vidyasagar Award, Govt. of West Bengal

1983 : Fellowship, The British Film Institute

1985 : D. Litt., Calcutta University; Dadasaheb Phalke Award, India; Soviet Land Nehru Award, Soviet Union

1986 : Fellowship, Sangeet Natak Academy, India

1987 : Légion d'Honneur, France; D. Litt., Rabindra Bharati
University, India

1992 : Academy Award for Lifetime Achievement, USA; Akira
Kurosawa Award for Lifetime Achievement, San Francisco
International Film Festival; Bharat Ratna, India

INDEX

PRESERVING A LEGACY

SOME TIME AFTER Satyajit Ray passed away, a number of actors and public personalities – Amitabh Bachchan and the late Ismail Merchant among them – teamed up to form what is today the Society for the Preservation of Satyajit Ray Films, popularly known as Satyajit Ray Society or just Ray Society. It was founded with the objective of restoring and preserving the priceless heritage left by the master director as also disseminating his work worldwide.

When Ray breathed his last in 1992, negatives and prints of many of his films, especially those of his early classics, were in a precarious state. David H. Shepard, a noted film preservationist in California, came to India in 1994 to examine the original negatives of the Ray films. He found negatives of eighteen of his films in 'tatters'. Restoration of Ray films was the Society's primary concern at the time. It went into a tie-up with the Los Angeles-based Academy of Motion Picture Arts and Sciences, the hallowed institution which had conferred the Oscar for Lifetime Achievement on Ray. So far, nineteen of the maestro's thirty-six-film oeuvre have been restored at the Academy Archive. More are waiting there to mount the restoration anvil.

Apart from his films, Ray left behind an astonishingly wide artistic universe comprising scripts, storyboards, posters, set, costume and book jacket designs, literary manuscripts, illustrations, music notations, advertisement artworks and so on. The Society has arguably the largest and most authentic archive on Ray in its custody. A veritable treasure trove, the Ray paper archive contains almost the entire creative output of his many-faceted genius. A large part of Ray's paper legacy has been

restored under the supervision of Mike Wheeler, Senior Conservator (Paper Preservation) at the Victoria-Albert Museum, London, and is housed in his family home in Kolkata. The large personal library that Ray left as well as his personal effects is also being carefully preserved.

The Society is committed to preserving this precious heritage for future generations of film lovers and scholars by giving them ready access to a one-stop repository on Ray's luminous creative output. With this in mind, the Society plans to set up, in a phased manner, a Satyajit Ray Heritage Centre, complete with a library, study centre, an auditorium and exhibition and seminar halls, for promoting awareness of Satyajit Ray and his work and its dissemination among lovers of art, literature and films.

The Society appeals to donors in India and abroad to help it give Ray's splendid heritage a permanent home in Kolkata, the city where he was born, raised and worked all his life, also the city he loved so much and celebrated in many of his films and literary works.

 SOCIETY FOR THE PRESERVATION
OF SATYAJIT RAY FILMS

www.satyajitrayworld.com
satyajitray.society@rediffmail.com
satyajitraysociety@gmail.com